Art in Context

Van Dyck: Charles I on Horseback

Art in Context

Edited by John Fleming and Hugh Honour

Each volume in this series discusses a famous painting or sculpture as both image and idea in its context – whether stylistic, technical, literary, psychological, religious, social or political. In what circumstances was it conceived and created? What did the artist hope to achieve? What means did he employ, subconscious or conscious? Did he succeed? Or how far did he succeed? His preparatory drawings and sketches often allow us some insight into the creative process and other artists' renderings of the same or similar themes help us to understand his problems and ambitions. Technique and his handling of the medium are fascinating to watch close-up. And the work's impact on contemporaries and its later influence on other artists can illuminate its meaning for us today.

By focusing on these outstanding paintings and sculptures our understanding of the artist and the world in which he lived is sharpened. But since all great works of art are unique and every one presents individual problems of understanding and appreciation, the authors of these volumes emphasize whichever aspects seem most relevant. And many great masterpieces, too often and too easily accepted and dismissed because they have become familiar, are shown to contain further and deeper layers of meaning for us.

Art in Context

*Anthony van Dyck, painter and etcher, was born in Antwerp on 22 March
1599 and died in London on 9 December 1641. He was the seventh son
of a prosperous Antwerp merchant and became the most brilliant and inter-
nationally successful seventeenth-century Flemish painter after Rubens.
He was trained in Antwerp, partly under Rubens, and in 1620 went to
England in the service of James I. Between 1621 and 1627 he was in Italy,
mainly in Genoa. He then established his studio in Antwerp until 1632
when he returned to England, being knighted by Charles I the same year.
He remained in England until his death, apart from two short visits to
Brussels in 1634 and to Antwerp in 1640.*

*Charles I on Horseback is painted in oil on canvas (3.67 x 2.92 m).
It was presumably commissioned by the king, probably in about 1638,
and Charles I's collection mark is stamped or painted on the back of the
original canvas, now relined. It has been in the National Gallery,
London, since 1885.*

Allen Lane The Penguin Press

Van Dyck: Charles I on Horseback

Roy Strong

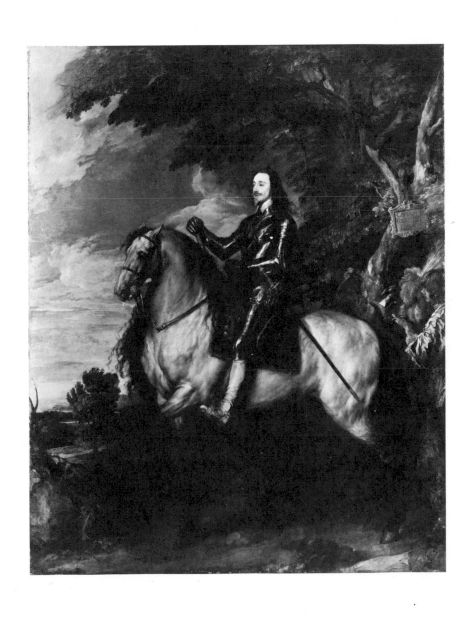

Copyright © Roy Strong, 1972
First published in 1972
Allen Lane The Penguin Press, 74 Grosvenor Street, London W1
ISBN 0 7139 0227 2
Filmset in Monophoto Ehrhardt by Oliver Burridge Filmsetting Ltd, Crawley, England
Colour plate printed photogravure by D. H. Greaves Ltd, Scarborough, England
Printed and bound by Jarrolds, Norwich, England

Designed by Gerald Cinamon

To the memory of Francis Wormald

Reference colour plate at end of book

Preface

This book began as a lecture to the Society of Antiquaries in 1967. It grew out of a study of both the portraits of Elizabeth I and, more particularly, of the relationship of Henry VIII and Holbein. As in the case of the latter, the main purpose of this book is to relate the royal image as conceived by a great artist to the politico-religious and cultural background of a court. In what is virtually little more than an evocative essay, many complicated themes and ideas could not be developed. These will be dealt with in greater detail in the introductory chapters to the complete edition of Inigo Jones's masque designs which is now in preparation.

I am grateful to several friends for their pertinent suggestions on the presentation of the material, in particular the editors, Hugh Honour and John Fleming. Dr Sylvia England has checked the text with her customary patience and enthusiasm.

London, July 1970

Historical Table

1625	(27 March) Charles I succeeds to the throne
	(13 June) Marries Henrietta Maria, daughter of Henry IV
1628	Petition of Right presented to Charles I
	Assassination of Buckingham
1629-40	The so-called Eleven Years Tyranny. Charles I rules without Parliament

1630

1632	Battle of Lutzen. Death of Gustavus Adolphus
1633	Charles I crowned King of Scotland in Edinburgh
	William Laud becomes Archbishop of Canterbury
1634	Ship Money reimposed by Charles I
1635-40	

c. 1637

1637	John Hampden's trial in London
1639	Invasion of Scotland

1640	The Long Parliament meets

1641	Execution of Strafford
1642	Outbreak of Civil War between King and Parliament
1644	Royalists defeated at Marston Moor
1648	Treaty of Westphalia ends the Thirty Years War
1649	(30 January) Charles I executed

		1625
Charles I buys the Mantua collection		1628
Rubens visits England (1629–30)		
Le Sueur's equestrian statue of Charles I (now at Charing Cross)		1630
Van Dyck settles in England	Milton's *L'Allegro* and *Il Penseroso* published	1632
		1633
	Milton's masque *Comus* performed at Ludlow	1634
Van Dyck paints *Charles I on Horseback*		1635–40
	Francis Quarles's 'Emblems' published	1635
Rubens's Whitehall Banqueting House ceiling canvases placed in position		*c.*1637
Bernini's bust of Charles I arrives in England		1637
		1639
Negotiations with Jordaens for the decoration of the Queen's House, Greenwich	The last of the masques *Salmacida Spolia* performed	1640
Rubens dies in Antwerp		
Van Dyck dies in London		1641
		1642
		1644
		1648
	The *Eikon Basilike* published and Milton's answer, the *Eikonoklastes*	1649

1. Prologue: King and Painter

The face of the court was much changed in the change of the king, for King Charles was temperate, chaste, and serious; so that the fools and bawds, mimics and catamites, of the former court, grew out of fashion; and the nobility and courtiers, who did not quite abandon their debaucheries, had yet that reverence to the king as to retire into corners to practise them. Men of learning and ingenuity in all arts were in esteem, and received encouragement from the king, who was a most excellent judge and a great lover of paintings, carvings, gravings and many other ingenuities . . .'

Memoirs of Colonel Hutchinson, *c.* 1664, first published 1806

The portraits of Charles I by Sir Anthony van Dyck represent one of the most famous ruler-painter relationships in the history of art, comparable to that of Holbein and Henry VIII or Velasquez and Philip IV.[1] Although this is a well-known fact, no one seems to have attempted to explain the background and motivation of this extraordinary combination, one so potent that it still affects the judgement of those fascinated by the romance of the Cavaliers. *Charles I on Horseback*, in the National Gallery, London, is among the most potent of all these images created as lasting monuments to the saga, one which immortalized a decade of Charles's reign, the so-called years of Personal Rule, when the king governed without Parliament as an absolutist Monarch by Divine Right. In this vast canvas, twelve feet in height, Charles rides a huge horse, standing beneath an oak tree in the midst of a forest glade. The image is the seemingly familiar one of sad-eyed elegance [1] and although Charles imperiously grasps a commander's baton and holds himself erect in the saddle, there is that touch of pensive melancholy which is never far absent from any of Van Dyck's numerous renderings of the king.

Over twenty years earlier Charles, then Duke of York, had been painted by Robert Peake the Elder [2]. Placing this picture by the

1. *Charles I on Horseback*, detail

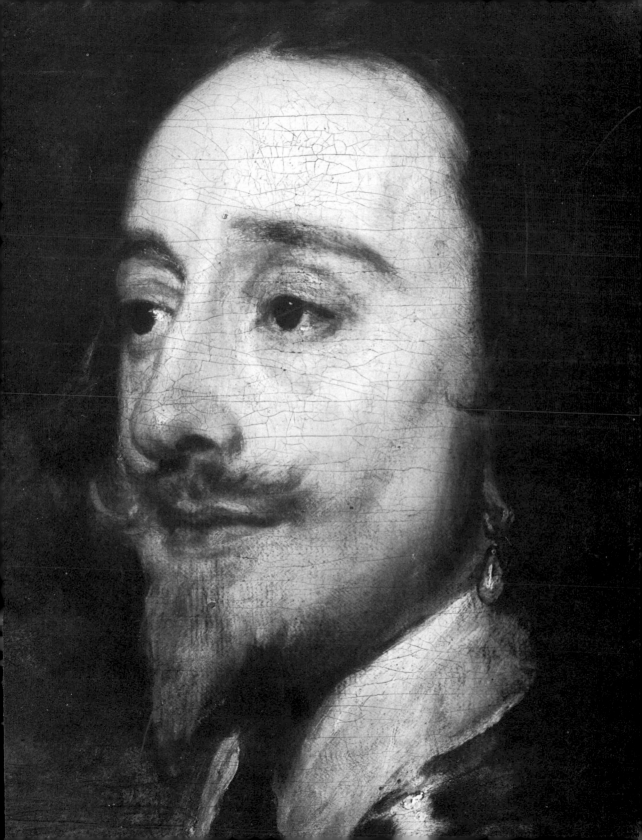

side of Van Dyck's *Charles I on Horseback* it is difficult to believe that they can have any connection at all, let alone that they depict the same person [3]. In just over two decades Charles I has been transformed from a Jacobean child icon, the product of the workshop of an old-fashioned court portraitist, to a hero immortalized

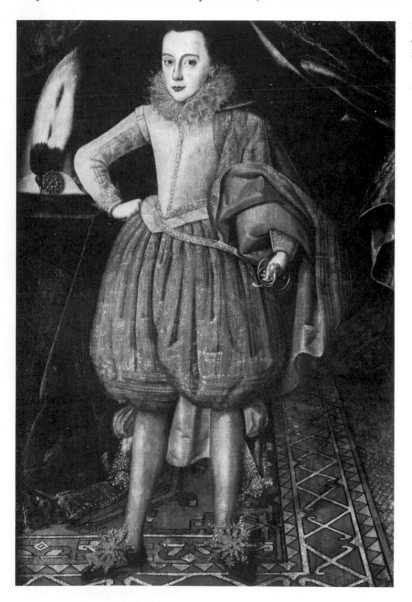

2 *(left). Charles I as Duke of York,* c. 1610-12.
Robert Peake

3 *(right).* Detail of 2

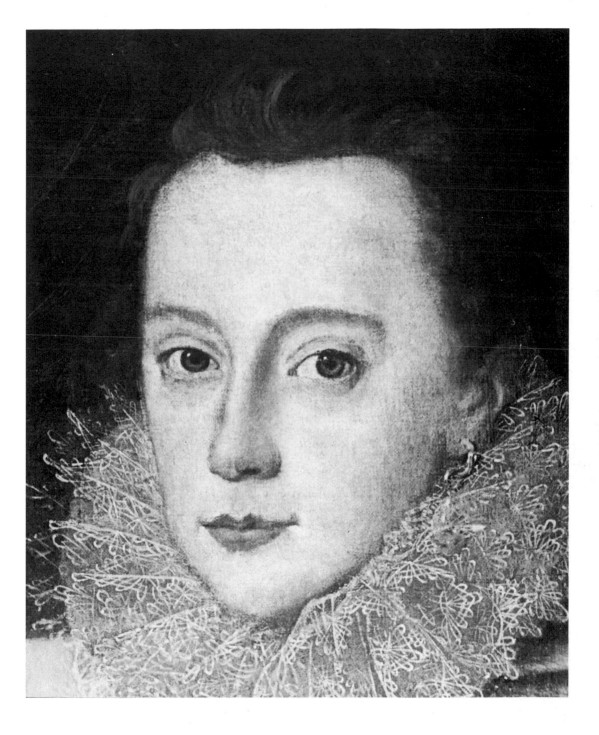

by the greatest portrait painter ever to be in the service of the English Crown. The juxtaposition of these two pictures epitomizes the stylistic revolution that Van Dyck's work in England represents and at the same time sets out in visual terms the aims of creators of royal images in the Baroque period.[2]

It is not necessary to linger long over the biographical details of the artist's life.[3] As Rubens's most brilliant pupil Van Dyck had already been attracted to the service of the king's father, James I, who gave him a pension of £100, and sent him off to Italy to finish his training. Thereafter the English court lost track of him until nine years later, in 1629, when Charles I purchased the painter's *Rinaldo and Armida* through Endymion Porter. Three years passed before the artist was finally welcomed to England into royal service on unprecedented terms that included a knighthood. Thenceforward, apart from visits to Flanders in 1634 and 1640, he was in England until his death in December 1641. These are commonplaces in the history of art. In the same way, it is recognized that his supreme achievement was the creation of a vision of the English Crown and court known to everyone since then at a glance. Not only did he revolutionize English painting but he had a profound influence on its development over the next two hundred years. Van Dyck shattered the tradition of the icon makers of Tudor and Jacobean England so completely that both pictures and painters slipped into oblivion: indeed no one has been able to look at them again seriously as art until our own day.

But a study of the Van Dyck portraits of the king, queen and royal family and of the aristocrats and gentry that made up the court, purely in terms of style, of formulae, pose and technique, of borrowings and individual developments, would not explain everything about Van Dyck in England. For instance, the artist's English portraits are recognized on stylistic grounds alone as having a quite different feeling and mood from those painted in his Italian or Antwerp periods. They are quieter in key, there is less impasto in the handling of the paint, less flamboyant drama in the presentation of his sitters. Yet all this cannot be explained solely in terms of style.

These portraits must also reflect the climate of the English court during the 1630s, the aims of Charles I and his circle as expressed in their artistic policies. To view Holbein without relating him to royal propaganda of the English Reformation is now recognized as absurd. It would be no less so to consider Van Dyck without placing him firmly within the framework of the poets, painters, sculptors and stage designers who worked to create a *mise-en-scène* for a Monarch by Divine Right.

For one of Van Dyck's major representations of Charles, the equestrian portrait in the National Gallery, London, is surprisingly

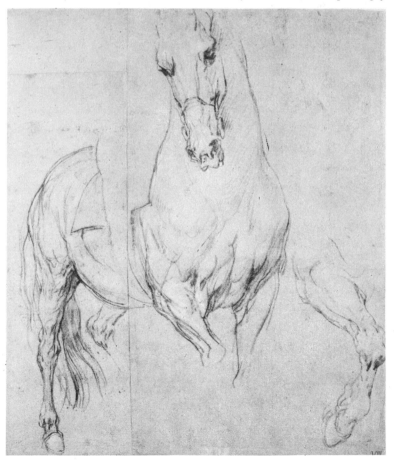

4. Sketch for the Great Horse, *c*. 1638. Van Dyck

meagre in its documentation.[4] There is a drawing from life of the great horse upon which an anonymous rider is astride [4] and a controversial smaller version of the portrait in the Royal Collection [5]. The latter is almost certainly that catalogued by the Keeper of the King's Collection, Abraham van der Doort, as the 'first model' when it was in the Chair Room at Whitehall. Experts are divided as to whether this can be accepted as the *modello* or not, and it is now argued that this version is mostly studio work, a reduction after the original.[5] The differences are minor: there is less sky and foliage, the horse is placed in deeper perspective than the drawing, and there are other minor variations. But as it shows no major rethinking on Van Dyck's part it adds little of importance to the story.

The National Gallery portrait is not dated, nor is there any documentation that can definitely be linked to it. Obviously it must be post 1632, when Van Dyck was appointed King's Painter, and pre 1637–40, the date of its first listing in the catalogue of the Royal Collection. The armour is no help either, being one of a series of armours for tilt and combat produced by the Greenwich workshops between 1610–20. Ironically under Charles I the exercise of tilt, tourney and barriers was entirely abandoned as a vehicle for courtly spectacle. The last barriers had been held by the Inns of Court in 1616 on Charles's creation as Prince of Wales, and the last tilt, at which the Prince had wished to flaunt a feather bestowed on him by the Infanta, would have been held in 1622 had it not been abandoned due to bad weather.[6] A solitary clue is the abbreviated collar, a fashion which belongs certainly to the late sixteen thirties when the falling band began to shrink in size. Perhaps we should postulate a date somewhere around 1638.

Van der Doort, the Keeper of the King's Collection, listed it as 'at present' in the Prince's Gallery at Hampton Court which indicates possibly that its final destination had not been settled.[7] Wherever it was finally to have been sited it belongs to a series of canvases which were all conceived as *coups de théâtre* at the end of great galleries in the various royal residences. All are illusionistic paintings

5. *Charles I on Horseback,* *c.* 1635. Attributed to Van Dyck

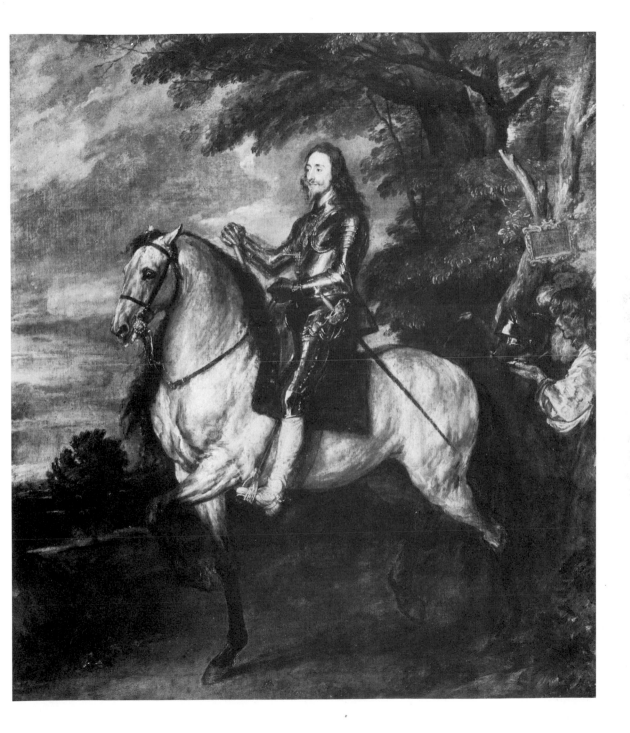

on the scale of scene painting meant to remove the wall from the viewer's eye in the same way as a Baroque ceiling painting [6]. The first of the series is the earliest picture Van Dyck ever painted for Charles, the 'great piece of our royal self consort and children' which

6. Conjectural hanging of *Charles I on Horseback*

7. Charles I and family,
c. 1631–2. Van Dyck

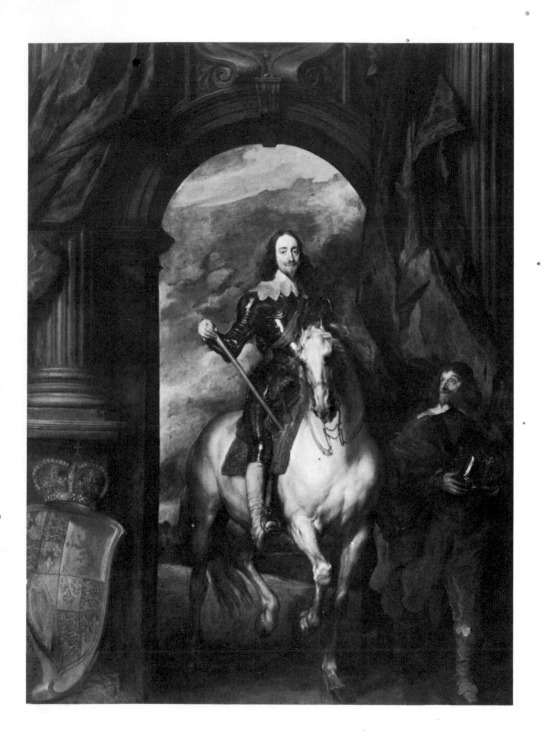

8. *Charles I
riding through a triumphal arch*,
1633. Van Dyck

hung at the end of the king's Long Gallery at Hampton Court[7].[8]
The second was an earlier version of Charles on Horseback, this time
riding through a classical triumphal arch attended by his riding
master, Pierre Antoine, Sieur de St Antoine [8]. This was placed at
the end of the gallery at St James's and its allusions to imperial
grandeur and antique triumph rounded off a display of Roman
Emperors by Giulio Romano and Titian.

The history of *Charles I on Horseback* is a well-charted one.[9]

Over a year after the king's death his great collections were dis-
persed and sold. This huge equestrian portrait was purchased on
21 June 1650 by the king's old agent in Antwerp, Sir Balthazar
Gerbier, for £200. It was subsequently owned by Gisbert van
Ceulen of Antwerp, who sold it to the governor of the Southern
Netherlands, Duke Maximilian II Emanuel, Elector of Bavaria.
Soon after, it became involved in the hazards of war, being looted
from Munich by the Emperor Joseph I and presented by him to the
victorious John Churchill, Duke of Marlborough. 'I am so fond of
some pictures I shall bring with me', he wrote to his beloved Sarah
on 8 November 1706, 'that I could wish you had a place for them
till the gallery at Woodstock be finished, for it is certain there are
not in England so fine pictures as some of these, particularly *King
Charles on Horseback*, done by Van Dyck.' So it was that it came back
to England half a century after it had left these shores to remain in
the collection at Blenheim until the first Duke's impoverished
descendants sold it to the nation in 1885.

Before embarking on the search for the true significance of Van
Dyck's images of the king and of the great equestrian portrait in
particular it will be necessary to reconnoitre first some way forward
in time. History has frequently judged Charles I rather from his
death than from his life. The same statement might be made of Van
Dyck's portraits. So our minds must first be purged of all later
romance regarding Van Dyck as the Cavaliers' apologist in paint.
For, in fact, his sitters were as often Puritans as Cavaliers and he
died before the Civil War broke out. No one at the time regarded his

portraits as especially romantic, nor did they see in his represent-
ations of Charles the sad eyes of impending doom. Yet one still tends
today to read into Van Dyck's portraits of Charles a sadness,
melancholy and romance. When and how did all this come about?
We are inheritors of a set pattern of associations, over a century
old, both intellectual and emotional, when we see a Van Dyck por-
trait of Charles I. Even the present leading authority on Van Dyck in
England detects 'a prescient aura of martyrdom' in his portraits.[10]
And yet if we really think about it, why ever should he? They were
painted at the time to celebrate the happiness and glory of a king
who had no way of knowing his ultimate fate.

2. The Mournful King

I go from a corruptible to an incorruptible crown, where no disturbances can be.

Charles I on the scaffold, 1649

During the optimistic sixteen thirties when Van Dyck painted the king, it would never have occurred to anyone that the portraits of Charles I were in any way sad. Why should they have been? In 1637 he declared himself the happiest king in Christendom; the halcyon years of Personal Rule, as seen through the eyes of an unrealistic court, were a period of carefree happiness and seeming political triumph.[11] The king's general appearance was frequently described by contemporaries, but specific references to his face came late in the reign and belong to the Civil War period. The first occurs in Sir John Denham's *Cooper's Hill*, published in 1642, although written earlier. In one version of his poem Charles is equated with the patron of the Order of the Garter, St George:

> *In whose Heroic face I see the Saint*
> *Better expressed than in the liveliest paint,*
> *That fortitude which made him famous here,*
> *That heavenly piety, which Saints him there,*
> *Who when this Order he forsakes, may he*
> *Companion of that sacred Order be . . .*[12]

The face of the king is here openly described as combining the virtues of a saint worthy of heaven. Later, when Charles was laid low by fortune, Lovelace gives a moving and probably very influential description of the royal face in his poem on the king's meeting with his son, the Duke of York, shortly before his execution:

> *See! What a clouded majesty, and eyes*
> *Whose glory through their mist doth brighter rise!*
> *See! What an humble bravery doth shine,*

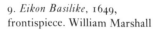

The Explanation of the EMBLEME.

Ponderibus *genus omne mali, probrisq; gravatus,*
(Vixq; forenda ferens. Palma ut Depressa, resurgo.

Though clogg'd with weights of miseries
Palm-like Depress'd, I higher rise .

Ac, *velut undarum* Fluctûs Ventiq; *furorem*
Irati Populi Rupes immota repello .
Clarior è tenebris, *cœlestis stella, corusco.*
(Victor et æternùm—felici pace triumpho.

And as th'unmoved Rock out-brave's
The boistrous Windes and rageing waves :
So triumph I. And shine more bright
In sad Affliction's Darksom night .

Auro Fulgentem *rutilo* gemmisq; micantem ,
At *curis* Gravidam *spernendo* calco Coronam.

That Splendid, but yet toilsom Crown
Regardlesly I trample down .

Spinosam, *at ferri* facilem, *quo* Spes mea, Christi
Auxilio, Nobis *non est* tractare molestum .

With joie I take this Crown of thorn ,
Though sharp, yet easie to be born .

Æternam, *fixis fidei, semperq;—*beatam
In Cœlos oculis Specto, Nobisq; *paratam.*

That heav'nlie Crown, already mine ,
I View with eies of Faith divine .

Quod Vanum est, *sperno; quod* Christi Gratia *præbet*
Amplecti studium est: Virtutis Gloria *merces*

I slight vain things; and do embrace
Glorie, the just reward of Grace .

G.D.

Τὸ Χῖ οὐδὲν ἠδίκησε τὴν πόλιν, οὐδ' τὸ Κάππα .

And grief triumphant breaking through each line
How it commands the face! So sweet a scorn
Never did happy misery adorn![13]

This is the only time within the king's lifetime that any hint of sorrow was detected in his eyes. That they were misty with tears was, of course, correct for the dramatic situation Lovelace describes. Two centuries later the sorrowing eyes were to become a standard ingredient of every description of Charles I at any period of his life.

Of the two contemporary eulogies of the king's face Sir John Denham's was the more accurate prognostication for on 30 January 1649 Charles I stepped out of a window of the Whitehall Banqueting House to be executed at the hands of regicides. He immediately became the subject of popular and propagandist 'canonization' and overnight the Church of England found its Counter-Reformation Baroque royal saint. Reliquaries of Charles I appeared, handkerchiefs dipped in his blood achieved miracles and his execution was seen and built up as a second Passion sequence. 'Far worse than Pilate', runs one of the more maniacal sermons preached to the exiled Royalist court in The Hague, 'the high Priests, Scribes, and Pharisees, who have lately murdered (if not the Lord of glory, yet I am sure) a glorious Lord though not Christ the Lord, yet the Lord's Christ, God's anointed . . . a most lively image of Christ, so lively an image of him, that amongst all the martyrs, who followed Christ into heaven, bearing his cross, never was there any who expressed so great conformity with our Saviour in his sufferings, as he did.'[14]

And the image that was to promote the cult was a Christ image, William Marshall's famous engraving at the front of the *Eikon Basilike* [9], copies of which were on sale in London the very day of the king's execution. Here Charles is depicted kneeling in silent ecstasy clasping Christ's crown of thorns, spurning underfoot the earth and his temporal crown, his eye fixed on a heavenly, star-encompassed diadem. To the left, emblems of his constancy in the path of virtue are a palm tree laden with weights (traditionally a

palm tree's upward growth is steadied by the weights attempting to drag it down) and a rock, which remains unmoved in the midst of turbulent waters.[15]

The initial text upon which the *Eikon* image is based occurs in Charles's meditation on his departure for London on 10 January 1642 in which he vowed never to abandon truth, justice, the rights of the Church and Crown and the good of his kingdom: 'I will rather choose to wear a crown of thorns with my Saviour than to exchange that of gold, which is due to me, for one of lead . . .'[16]

This statement develops in more positive form the King-Christ equation which the king's father had hinted at in his *A Paterne for a King's Inauguration*, written in 1619, in which he discusses the crown of thorns: 'That King, therefore, who will take his pattern from this heavenly King must not think to wear a crown of gold and precious stones only, but it must be lined with thorns, that is, thorny cares.'[17] If one had to point to a single iconographical source for the *Eikon Basilike* frontispiece it would be to representations of Christ in the Agony in the Garden. And the face in the engraving is a Van Dyck one with the fashionable hairstyle of the thirties that could so easily look Christ-like with its dilated, tearful eyes, centre parted hair, pointed beard and moustache. No wonder that at a much later date commentators began to see a likeness between Van Dyck's portrayals of Charles I and Christ.

At the Restoration in 1660 the cult of the Royal Martyr was officially sanctioned with a special service to be used in every parish church each 30 January and this was used, in varying forms, until the commemoration was finally abolished under Queen Victoria in 1859. Both in this special service and in the flood of sermons which were published year after year the King-Christ parallel continued to be used until well into the nineteenth century.[18] A prayer in the 1661 service runs as follows:

'Blessed Lord in whose sight the death of thy Saints is most precious, we magnify thy name for those wonderful effusions of thy grace on our late Martyred Sovereign, which enabled him so happily to transcribe the Copy of his blessed Master in a constant meek

suffering of all barbarous indignities, and at last resisting even unto blood, and even then, pursuing that glorious pattern, and praying for his Murderers.'[19]

Wren in 1678 was commissioned to erect a royal mausoleum incorporating a life-size statue of Charles borne up on a shield

10. *Charles I lying in State, c.* 1649. Anonymous

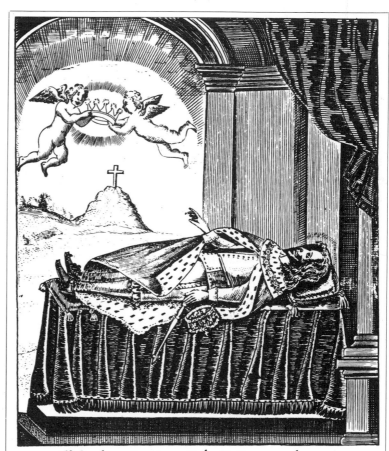

If Prudence, Temp'rance, Valor, Patience, zeale,
Could that dire doome of Mallice Arm'd repeale,
Thy life had blest vs long: but Englands sinns
Gaue way and strength vnto those fatall Ginns
Thy foes spread for thy life; and now wee see
Religion, Peace, Law, freedome, Dy'd with thee;
They keep their word; make thee a glorious King;
For thine's like to thy Sauiours suffering.

supported by heroic virtues crushing down Rebellion, Heresy, Hypocrisy and Envy, and above his head, cherubims carrying a celestial crown and the martyr's palm.[20] This was never executed but for over two hundred years every church-goer was reminded of Charles the Martyr and of his Christ-like sacrifice every 30 January [10].

John Evelyn was the first writer after Lovelace to take up the theme of the fated face. In his *Numismata*, published in 1697, forty-eight years after the king's death, he recounts, in the midst of a long dissertation on the value of the study of human physiognomy, that Bernini, '. . . who cut that rare *Bust* of *Charles the First* . . . from a Picture painted by Van Dyck [11] foretold something of funest and unhappy which the Countenance of that Excellent Prince foreboded'.[21] Where Evelyn, who is usually very exact, got this from we do not know and it is open to question whether any such statement would ever have been made except in retrospect. As a story it was too good to be left unembroidered by those anecdotists of British art, Horace Walpole and Allan Cunningham. Walpole in the mid eighteenth century wrote: 'It was on seeing this picture that Bernini pronounced, as is well known, that there was something unfortunate in the countenance of Charles.'[22] Over half a century later, in 1829, when Romanticism was in full flood, Cunningham makes Bernini say: 'Something evil will befall this man: he carries misfortune in his face.' To this Cunningham adds a splendid Roman omen; probably a total fabrication: 'Tradition has added in the same spirit, that a hawk pursued a dove into the sculptor's study, and, rending its victim in the air, sprinkled with its blood the finished bust of King Charles I. I have also heard it asserted, that stains of blood were still visible on the marble when it was lost in the fire which consumed Whitehall.'[23]

Most people in the eighteenth century did not see Charles I's face as particularly fated or sorrowful. Indeed, in one of the earliest dramatizations of his life, that by W. Havard, presented at the

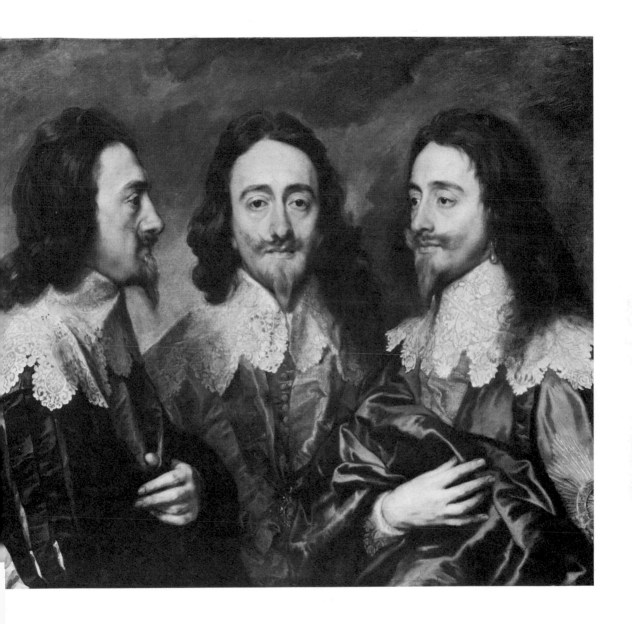

11. *Triple Portrait of Charles I*, 1636. Van Dyck

Theatre Royal in Lincoln's Inn Fields in 1737, exactly the opposite is said. He is described at the trial as having a face wreathed with smiles not sorrow:

> *Such was his look – such awful majesty*
> *Beam'd out on every side, and struck the gazer,*
> *No mark of sorrow furrow'd up his face,*
> *Nor stopp'd his smiles to his saluting friends,*
> *Clear as his conscience, was his visage seen,*
> *The emblem of his heart . . .*[24]

Even on the scaffold Charles refuses to betray 'one sorrowing look'. Nevertheless the play has several of the standard ingredients beloved of the Romantics: the tearful farewell to his children, a confrontation of the king with Oliver Cromwell and Henrietta Maria, the exiled Queen, mysteriously in England in 1649.

The fact that Charles's life had reached the stage as a Shakespearian drama, as it was billed by its author W. Havard, meant that the king was material for an heroic saga worth depicting by both men of letters and painters of history. This probably relates to the publication in 1705–7 of Clarendon's *History of the Great Rebellion* which ran into several editions and removed Charles firmly from the area of hagiography into that of history and historical adventure. This is corroborated too by the spectacular series of canvases commissioned by Peregrine Osborne, Duke of Leeds in about 1722, of the life of Charles I.[25] Many if not all of these were engraved and provided subjects for history painters for the next century and a half. There may have been a touch of Jacobitism in this commission for, although Osborne had supported the invasion of William of Orange, he had no sympathy for the new house of Hanover, advocating rather 'the restoration of our only true and rightful King James III'. Ten scenes tell Charles's life story. Some are factual: the battle of Edgehill, the siege of Hull and the king's marriage. Others are conceived in terms of high melodrama: the king's arrest, his escape from Hampton Court and his trial, com-

plete with a protesting Lady Fairfax. There is also an outright precursor of the worst excesses of Victorian sentimentality, Charles I saying farewell to his children [12]. The series closes with a Rococo assumption into heaven. Although Charles is finally celebrated as the martyr borne into eternal bliss amidst cherubims, the series as a whole is not connected with the cult of the king as a saint,

12. *Charles I
bids farewell to his children,*
1722. Jean Raoux

but as the hero of a romantic historical drama. These pictures belong firmly to an emergent historicism of a type which produced the familiar canvases by William Kent of Henry V or the Black Prince.

In these paintings a great attempt is made at accuracy in Cavalier costume and here we strike what was probably a major aspect of the eighteenth-century attitude to the seventeenth. In the revolt against the Baroque, Lord Burlington had reverted to the principles of Palladio as embodied in Inigo Jones and his return back to the Caroline period is reflected also in a passion for dressing in Van Dyck costume. At the beginning of George II's reign people appeared at masquerades attired in Cavalier costume and sat for their portraits wearing the same.[26] It was a fashion which lasted into the early years of the next century. Hence the associations of Van Dyck and his sitters were, to his eighteenth-century admirers, predominantly those of adventure, heroism, courtly romance and good taste. Certainly the Duke of Marlborough would never have commissioned Bernard Lens to make a miniature of the equestrian portrait with his own features replacing the king's if the associations had been those of doom.

Romantic interest in the English Civil War had its origins in France as much as in England.[28] Cromwell had begun to attract French attention in the middle of the eighteenth century. In 1764, for instance, the Parisian public was presented with two plays about Charles and Cromwell – one on the stage, the other in print – and both, according to the *Correspondance Littéraire*,[29] very bad. And in Italy G. B. Alessandro Mareschi's play *Carlo I Re d'Inghilterra* was published in 1783. But it was not until after 1815 that the subject began to enjoy widespread popularity. It had, indeed, acquired a topical significance, for as Chateaubriand pointed out in his *Essai sur les révolutions*, those of the past helped to explain the phenomenon of the French Revolution, though Guizot, in his influential *Histoire de la Révolution d'Angleterre* of 1826–7, reversed this comment and declared 'that the first would never have been thoroughly understood had not the second taken place'. The young Balzac

wrote a play about Charles I and Cromwell in 1818, Villemain's *Histoire de Cromwell* appeared in the next year and several plays were devoted to the same theme before Victor Hugo began his famous *Cromwell* in 1826 and broke new ground by concentrating on a later period of the Protector's life. Shortly afterwards, in 1830, in Germany E. Kaiser wrote a *Trauerspiel* about Charles, and a decade later Frans Bermoth wrote another. In Italy Paolo Giacometti's play entitled *Carlo I. Re d'Inghilterra* was described as a '*commedia*'! In England Shelley began a play about Charles I in 1819 but left it unfinished. Tragedies about Charles were however written by E. Cobham in 1828, by Mary Russell Mitford in 1840 and by the Rev. A. T. Gurney in 1846. On a somewhat higher literary plane there was Browning's *Strafford* of 1837, which characterized the king as 'the man with the mild voice and the mournful eyes'.

Walter Scott has been credited with much influence in the romantic cult of Charles I, but in fact his only Civil War book is one of his last novels and, as the title reveals, is set in the period of the Protectorate: *Woodstock: A Tale of 1651*. This was published in 1826 and was not translated into French until Hugo had already begun to write his great drama. Although a Stuart enthusiast, Scott was not one of the most fervent admirers of Charles I. Nevertheless, when he was given a hair from the king's head - after the body was disinterred at Windsor in 1813 - he had it encased in a gold ring inscribed with the favourite Jacobite legend *Remember* and wore it habitually. And in *Woodstock* he gives a vivid account of the power that Van Dyck's portraits of the king could exert. In the novel Cromwell uncovers, inadvertently, a portrait of Charles:

'That Flemish painter, that Antonio Vandyke - what a power he has! Steel may mutilate, warriors may waste and destroy - still the King stands uninjured by time; and our grandchildren, while they read his history, may look on his image, and compare the melancholy features with the woeful tale. - It was a stern necessity - it was an awful deed! The calm pride of that eye might have ruled worlds of

crouching Frenchmen, or supple Italians, or formal Spaniards; but its glances only roused the native courage of the stern Englishman . . . Then what is that piece of painted canvas to me more than others? No; let him show to others the reproaches of that cold calm face, that proud yet complaining eye . . .'[30]

The painter Northcote told James Ward, some time before 1830, that Van Dyck's 'portrait of Charles the First on the white horse has not a fellow in the world. The horse is not exactly like a horse, yet it is so beautifully delicate, and might be admitted into a drawing-room without offence. The head of Charles is extremely fine, and

13. *Cromwell gazing at the body of Charles I,* 1831. P. Delaroche

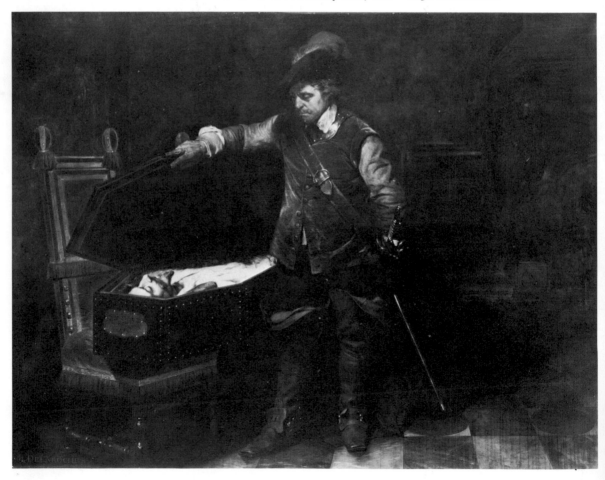

it might almost serve as a model to paint the Saviour from.'[31] Religious implications of the story of Charles were taken up by the French painter Paul Delaroche. In the Salon of 1831 he exhibited his famous picture of Cromwell gazing into Charles's coffin, like a figure meditating on the dead Christ, a work that was destined to provide the composition for a best-selling print throughout Europe [13]. Six years later he followed this up with *The Mocking of Charles I* where the Christian parallel is more explicit than ever [14]. In England Maclise had painted a picture on the same subject as Delaroche, Cromwell gazing at Charles I in his coffin and another

14. *The Mocking of Charles I*, 1837. P. Delaroche

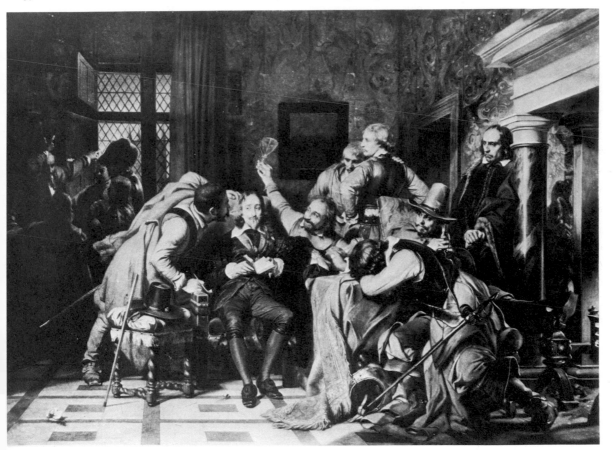

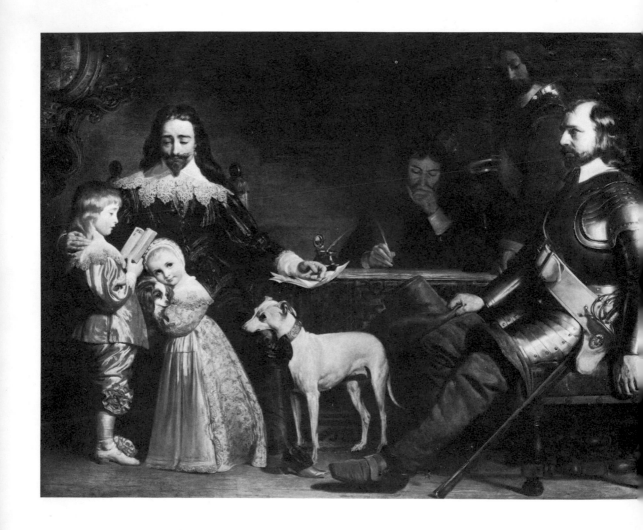

15. *Charles I and Cromwell*, 1836. Daniel Maclise

of Charles I with his children interviewing Cromwell [15]. It was but a little way to go to reach the excesses of Yeames's *And when did you last see your father?* where the legend of the sombre, horrid Puritans and the beautiful, innocent, persecuted Cavaliers is visually crystallized for all time. In the meantime Vincenzo Bellini's opera *I Puritani di Scozia*, based on a play *Têtes Rondes et Cavaliers* by François Ancelot and Xavier Boniface Saintine, had its debut at the Théâtre Italien, Paris. It is hardly surprising that, by then, not just the life of Charles I but also Van Dyck's portraits of him should have been varnished over with a haze of romantic melodrama.

'I do not know if the knowledge of history contributes to it', wrote Charles Blanc in 1864, 'but one is persuaded to distinguish in the pallid features of this prince harbingers of his tragic destiny.' He certainly yielded to persuasion. Describing the portrait of the King proudly riding through an archway, he remarked that his face was 'serious and melancholy as always'. Of *Le Roi à la Chasse* he wrote that the king carried with him 'sa mauvaise fortune et ses rêveries' and even noted in the horse 'a dismal, gloomy eye and a head lowered as if in sympathy with his melancholy thoughts'.[32] In 1881 Alfred Michiels in his *Van Dyck et ses élèves* describes the *modello* of our portrait in the following terms: 'All is sombre in this painting, the colour, the expression, the light. The King, sad and grave, seems, as always, troubled by baleful visions. Some great dark trees stretch their dense branches over his head. There is not a gleam in the landscape, not a ray of hope in the sky.'[33] Michiels dwells at greater length on the face when discussing the Windsor equestrian portrait [6]: 'But, in his eyes, in his physiognomy, in his whole person, there is an expression of sadness, a cool, deep, permanent, organic (if one may so describe it) and incurable sadness. He seems as if pursued, tormented by some mysterious affliction.'[34] Max Rooses thirty years later invests the portrait with especial pathos. Here, he said, Charles 'seems to turn his large listless eyes instinctively towards heaven with a tired and melancholy expression as if he were reading in the clouds his fateful end'.[35]

From this time on some references to sadness became almost obligatory in descriptions of Van Dyck's portraits of Charles. Louis Gillet, writing of the Louvre portrait, described it as 'radiant' and 'sad', adding that the picture presents a moment of the past 'in an indescribable atmosphere of legend and poetry'.[36] Emil Schaeffer said that he gazes with 'pensive melancholy in the evening landscape'[37] and Gustav Glück found him looking out of the picture with 'a mournful countenance'.[38] As recently as 1947 A. J. Delen wrote that Van Dyck expressed in his portraits Charles I's 'delicate refinement, anaemic melancholy and tired resignation'. He described the Louvre portrait in the following terms:

'The noble, almost tender figure . . . is standing almost dandy-like in front of a beautiful landscape . . . But we sense a different truth, a tragic truth therein. In these sad eyes and on these narrow bitter lips, there lies as it were all the mystery of gnawing anxiety.'[39]

Van Dyck died in 1641 and it need hardly be stressed that at that date – and for several years after – no one could have divined Charles's future. Ought we then to dismiss all these comments out of hand? Other sovereigns have come to violent ends without their portraits being supposed to contain tragic premonitions. Only the most wilfully imaginative could see forebodings of doom in the portraits of Louis XVI or of the Emperor Maximilian. Why have they been seen in Van Dyck's of Charles I? Though Van Dyck cannot have foreseen the king's future, he did, unwittingly, provide abundant and suggestive material for the future cult of Charles the Martyr: indeed it is difficult to believe that this cult would have enjoyed – or could still enjoy – such widespread popularity, both in England and abroad, if the only visual records of Charles had been the crude engraving which prefaces *Eikon Basilike*, the numerous painted derivations from it, and the portraits by Mytens and other court painters of the day. In C. V. Wedgwood's memorable phrase: 'the inhibited, adenoidal face of King Charles, unflatteringly

rendered by Mytens, was transfigured by Van Dyck's hand with indefinable spiritual grandeur.'[40]

A spiritual, one might even say a religious aura, emanates from Van Dyck's portraits of Charles. Van Dyck reveals to us both the all-powerful god-appointed monarch and the sensitive, refined individual, elegant, world-weary and faintly languorous. Van Dyck's portraits have a curious 'combination of splendour and pathos' as Shorthouse remarked in *John Inglesant*.[41] How can this be explained? As I hope to show, *Charles I on Horseback* has many layers of meaning and these can only be understood in their historical context. For this great painting is by no means just an imposing royal portrait. It is a very complex image – rich in meanings and double-meanings. Charles is shown to us not only as 'the Lord's Anointed' but as 'Imperator': not only as a warrior but as a knight – and as a knight in the service of both religion and love: not only as St George but as Albanactus. He is shown to us as humanist – philosopher – Maecenas.

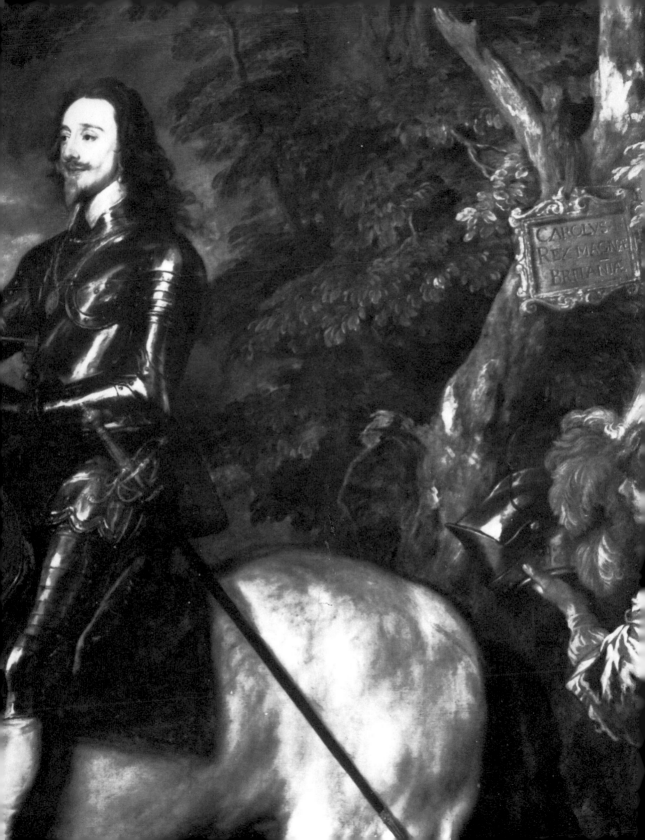

CAROLVS
REX MAGNÆ
BRITANIÆ

3. One Imperial Prince

And now she is, and now is peace; therefore
 Shake hands with Union, O thou mighty State!
Now thou art all Great Britain and no more;
 No Scot, no English now, nor no debate:
No borders, but the Ocean and the Shore:
 No wall of Adrian serves to separate
Our mutual love, nor our obedience;
Being all subjects to one Imperial Prince.

Samuel Daniel, *Panegyric Congratulatorie*, 1603

Tied to a branch of the tree to the right of the king in our portrait
is a tablet framed with elaborate scrolling with the Latin inscription:
CAROLVS I REX MAGNAE BRITANIAE [16]. Today, three hundred
and fifty years after the event, this might seem to be stating a com-
monplace; but in the 1630s the concept of a single monarch ruling
over a united Scotland and England still had the potency of a novel
idea.[42] The portrait is celebrating the event of 20 October 1604
when Charles's father, James VI of Scotland and I of England, pro-
claimed himself King of Great Britain: '. . . out of undoubted know-
ledge [we] do use the true and ancient name which God and time
have imposed upon this Isle, extant and received in histories, in all
maps and cartes where in this Isle is described . . .' In spite of this
the reality of political and judicial union was not achieved until a
century later in the Act of Union. It was not however that James
did not wish for the latter, indeed the proclamation was evidence of
his failure to obtain it. In the very first Parliament of the reign which
met in March 1604, a year after his accession, the question of the
king's style arose and a bill recognizing James as King of England,
Scotland, France and Ireland was passed. A Caernarvonshire M.P.,
Sir William Maurice, proposed that the king should be styled
Emperor and his dominions renamed Great Britain. A debate lasting

16. *Charles I on Horseback*, detail

three days ensued in the Commons, the opposition rallying and winning the point that the title should *follow* and not *precede* the union. James, considerably annoyed, referred the matter to the judges who in turn rejected the change as it would have wrecked the judicial system overnight. The whole matter was therefore placed in the hands of commissioners representing the two countries who met for the first time on the very day that James, under the influence of Francis Bacon, proclaimed himself King of Great Britain, flaunting his own prerogative in the face of Parliament, judges and commissioners. In a sense James had got what he wanted by forcing the issue but he never achieved a merging of the political and judicial systems. Attempts by Charles I to unite the kingdoms ecclesiastically, by the introduction into Scotland of both Bishops and the English Book of Common Prayer, directly precipitated the war which led to the collapse of the personal rule.

The historical fact that Van Dyck celebrates in the cartouche was in reality a dismal failure. But this never stood in the way of Crown and court, advocates of Divine Right, from extolling in panegyric what they already accepted from the very moment of James's accession as a *fait accompli*. Masques, poems, medals, eulogies and inscriptions sang of the benefits showered on this island by the Stuart assumption of the imperial British diadem. Resumption would be a better word, for both history and myth argued that the new dynasty had revived Ancient British glories. Both Tudors and Stuarts claimed descent from the Trojans who had first conquered this island and from Brutus, the first king of Britain.[43] Later there followed division and disunity which now, after these many centuries, had been brought to an end by the accession of James I, 'our second Brute and King'. The arch dedicated to *Nova Foelix Arabia* in James's coronation entry (1604) contains a simple statement on this political *renovatio*:

> *Great Monarch of the West, whose glorious stem*
> *Doth now support a triple diadem,*

Weighing more than that of thy great-grandsire Brute,
Thou that maiest make a King thy substitute,
And dost besides the red rose and the white,
With the rich flower of France thy garland dight,
Wearing above Kings now, or those of old,
A double crown of laurel and of gold.[44]

The theme of *renovatio* was to find its richest and most complex visual form in Rubens's panel celebrating *The Union of the Kingdoms* on the Whitehall Banqueting House ceiling.

But the theme has richer resonances in its theological aspects which those concerned with promoting the union particularly stressed in their sermons and pamphlets. The Anglican Church based itself on the historiographical myth of being the Ancient British Church revived, a return to primitive purity before it was polluted by the arrival of Augustine and his Popish monks. There is no need to go into the ramifications of this theme and a single quotation must suffice to evoke the implications of this in relation to the monarchy: 'The Britaines before all nations first publicly received the Faith of Christ; I must confess there was Faith and Religion before received in Jerusalem, in Asia, in Rome, France and Spain: but it was not so publicly embraced, in any place, by Kings and superior Magistrates: as it was then received by *Lucius*, King of Britannie, and by all his people,'[45] This interest in Lucius was eclipsed by an obsession with the Emperor Constantine, who was not only British by birth but the first Christian Emperor. The English Reformation was carried through on the imperial status of the kings of England, and both Tudor and Stuart monarchs were built up in succession as images of Constantine revived.[46]

For Charles, Thomas Carew's masque *Coelum Britannicum* usefully demonstrates the Caroline transmutation of the Ancient British theme. In this, Ancient British could become synonymous with Ancient Roman and so, for example, the new Palladian classical architecture of Inigo Jones could also be regarded as Ancient British.

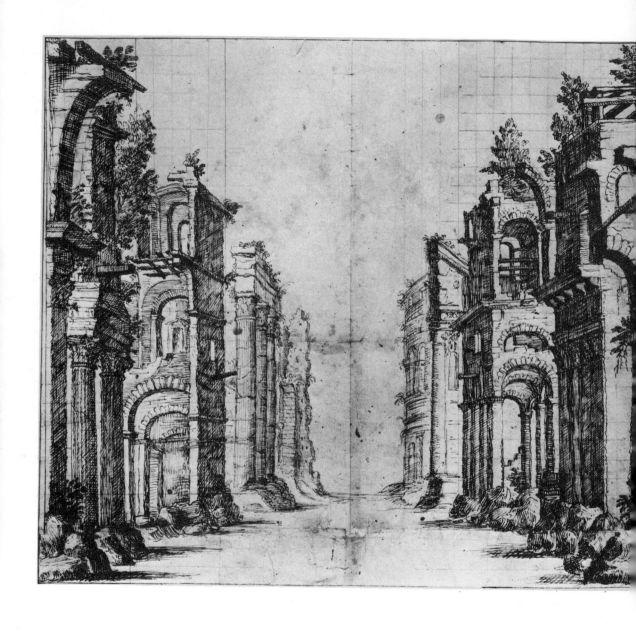

17 (*above*). Design for scene I of *Coelum Britannicum*, 1634. Inigo Jones

18 (*opposite*). Costume design for the king in *Coelum Britannicum*, 1634. Inigo Jones

A curtain flew up at the very opening revealing 'the ruins of some great city of the ancient Romans or civilised Britons' [17]. An anti-masque of Picts, Scots and Irish, who performed a grave Pyrrhic dance, was banished by the apparition of a vast mountain on which the three kingdoms 'all richly attired in regal habits' and the masquers, including the king, were discovered as British Worthies 'attired like ancient heroes' [18] with their flanking torch-bearers 'apparelled after the old *British* fashion'.[47]

Van Dyck's equestrian portrait therefore portrays Charles as both hero and emperor. The equestrian formula for a king who wore the triple diadem of empire was a natural one. Behind the vision of Charles I as a warrior on horseback seeking the solace of the greenwood tree a long tradition of portraiture stretches back to antiquity.[48] Hellenistic rulers were the first to depict kings on horseback as embodiments of majesty, and it is no coincidence that Apelles was said to have painted Alexander the Great in this way. Under the Roman Empire the equestrian portrait became a privilege reserved to the Emperor alone; the famous statue of Marcus Aurelius [19] remained to remind the Middle Ages and inspire the Renaissance with an art form, the epitome of all imperial aspirations. Verrocchio's *Colleoni* and Leonardo's abortive Sforza projects all glorify the prowess of the hero, a public celebration of his *virtù*. With the growth of absolutist states in the sixteenth century the form was taken over and used as a public assertion of dynastic authority. Titian's *Charles V* [21], which according to Bellori directly inspired Van Dyck's portrait, is a supreme statement of imperial triumph commemorating the Emperor's victory at Mühlberg, and fusing, like Charles I, antique heroism with knightly chivalry.

But this equestrian theme must be seen not only in its grandiose European context but also within the confines of established themes in the iconography of the English monarchy. The reverse of the Great Seals of England always contained an image of the monarch riding along on horseback [20]. In the case of Charles the knightly

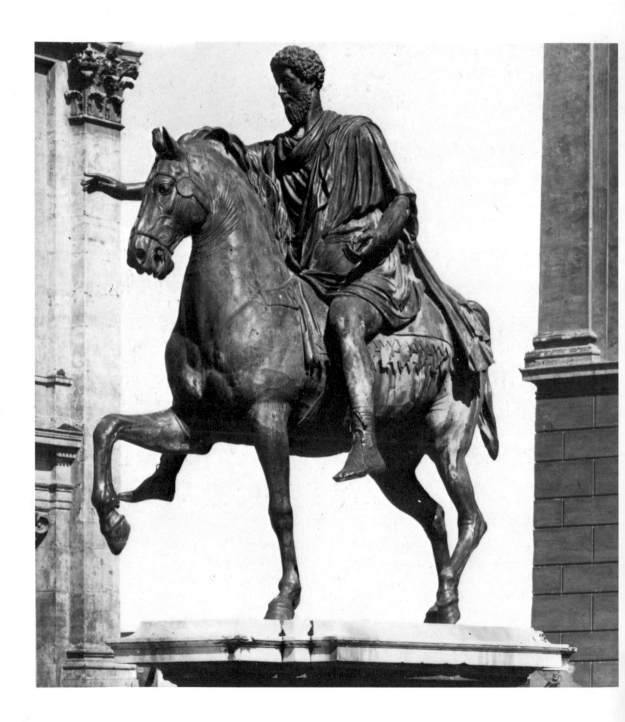

19 (*left*). *Marcus Aurelius*

20 (*below*). Reverse of the Third Great
Seal of Charles I, 1627–40

21 (*right*). *The Emperor Charles V*,
1548. Titian

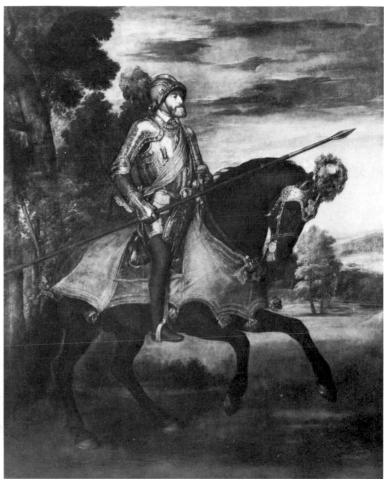

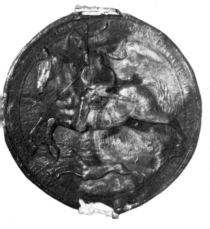

context is forcefully heightened: the horse bounds along and the
king menacingly brandishes his sword above his head. Although
there are other incidental representations of Tudor monarchs on
horseback it was not developed as a specific theme until after James
I's accession.[49] Following no doubt continental models English
engravers suddenly produced a number of portraits of members of
the royal family on horseback. As early as about 1613–14 Elstrack
engraved Charles, still a stiff Jacobean doll astride a horse, fringed

The high
and mighty PRINCE
CHARLES PRINCE of
Great Brittayn and Ireland
Duke of Yorke and Albany
Marquis of Ormont &
And Knight of the most
noble order of the
Garter.

ICH DIEN

Renold
Elstrack sculpsit

Are to be sould at the whit horse in Popes
head Alley by Iohn Sudbury and George Humble

From Two great kingdomes art: as in Royall bloud: May the faire spring in Sommers glory bud | Since in thy brest the hope of Brittayns Name
the Sacred stemmes of & in Ann: Alley | Euen to the height of Rule and Dignity | Ilyes hid: As in a Cabynet of Fame

22 (*left*). *Charles I as Duke of York,*
c. 1614-15. Renold Elstrack

23 (*right*). *Henry, Prince of Wales, c.* 1610
Attributed to Isaac Oliver

sashes and ribbons aflutter, trotting through the countryside [22].
It was clearly a best-seller as both head and hat, but not the rest,
were brought up to date twice. And there were two paintings – per-
haps the most significant representations of all – one of Charles's
brother, Henry, Prince of Wales, who was painted on horseback
about 1610-12 in a magnificent canvas [23], probably by Isaac
Oliver in the Venetian manner,[50] using a formula derived from

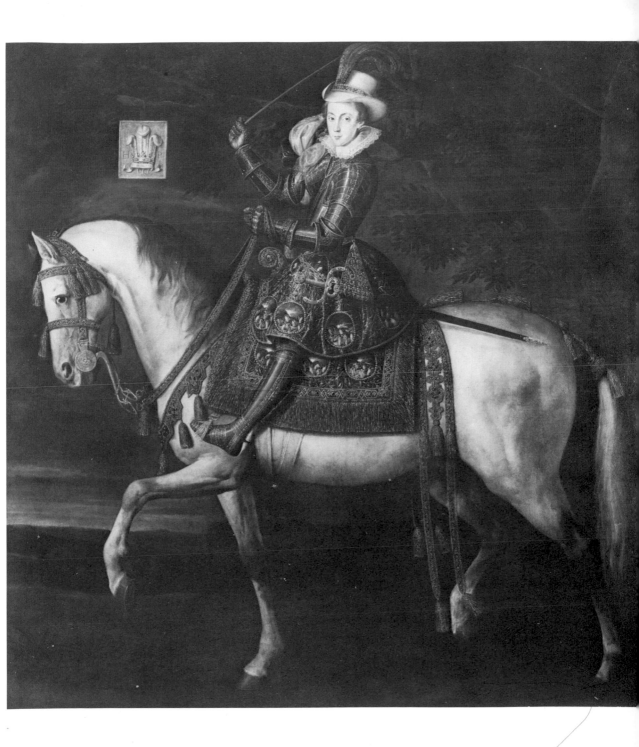

54

Clouet portraits of the Valois kings, and the other, Rubens's rendering of Charles's favourite, Buckingham, galloping along amidst a swirling mass of allegorical apotheosis [24].[51]

Charles appears specifically as *imperator* in the National Gallery picture and there should be no confusion with the complementary

24. *George Villiers, Duke of Buckingham,* 1627. Rubens

25. *Charles I
à la ciasse,*
1635.
Van Dyck

canvas in the Louvre of him *à la ciasse*[52] in leather doublet and high boots, his hand resting on a walking stick [25]. Charles *à la chasse* belongs to a tradition that includes Van Somer's portrait of his mother with her dogs and Peake's of Prince Henry with a dead deer at his feet. In the Louvre picture Charles is celebrated as the perfect *cortegiano*. He is depicted as a gentleman in quiet dress standing elegantly in a forest glade, his equanimity wholly undisturbed by the horse and servant behind him. Only in the ability to ride is there an allusion to the *cortegiano* theme in the National Gallery picture. Few other skills evoked such a response as that to ride a great horse and the horse in the picture is truly a great horse in the seventeenth-century sense of the term. 'Doth any earthly thing breed more

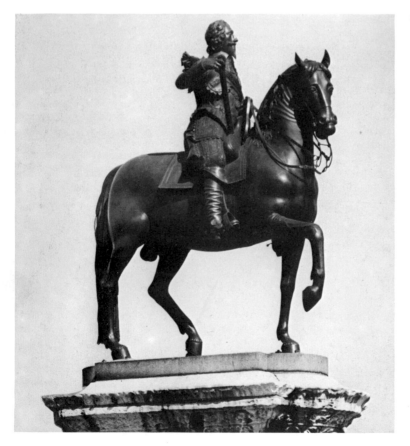

26. *Charles I*, 1630. Hubert Le Sueur

wonder', writes Morgan in his *The Perfection of Horsemanship*, published in 1609, 'and hath not the same from all beginning been heriditary in the most noble persons? how, then, shall not that action be accounted the most best and honourable, that is evermore performed by the best?'[53]

The *Carolus Imperator* of the Van Dyck portrait belongs specifically also to the context of three other imperial equestrian images of the king. One is the full length of 1633 in which he rides through a triumphal arch [8], the second is Hubert Le Sueur's equestrian statue now at the top of Whitehall but commissioned by Lord Weston for his garden at Roehampton in 1630 [26].[54] The third is a rejected design by Inigo Jones of 1636 for a triumphal arch at

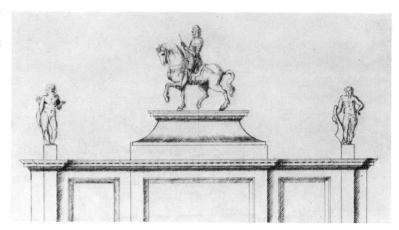

27. Detail of design for a triumphal arch at Temple Bar, 1636. Inigo Jones

Temple Bar surmounted by an equestrian statue [27]. All four are concerned with the adaptation for the king of Great Britain of the equestrian theme of the emperors of antiquity.

But it is important to grasp the enormous time lag. The 'imperial' style *à l'antique* had first been used with conviction in Italy in the fifteenth century. In the sixteenth century it travelled north over the Alps but it did not reach England until the early seventeenth century. The court of Charles I is the last great Renaissance court using freshly a mythology which had already run its course in the rest of Europe, in some cases, as much as a century before.

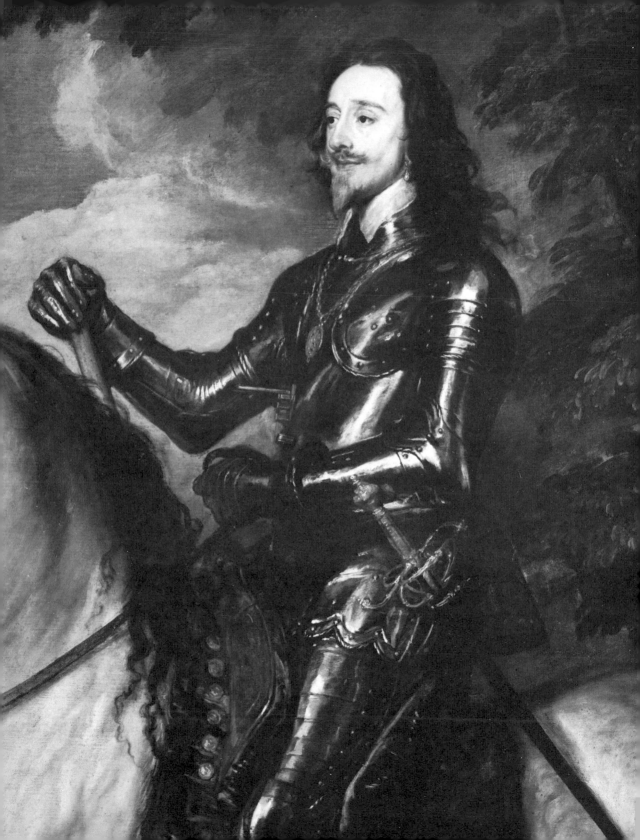

4. St George

Then, hand in hand, her Tames *the Forrest softly brings,*
To that supreamest seat of the great English Kings,
The Garters *Royal seat, from him who did advance*
That Princely order first, our first that conquered France;
The Temple of Saint George, *whereas his honored Knights,*
Upon his hallowed day, observe their ancient rites.

Michael Drayton, *Polyolbion*, 1613

28a, b. *Charles I on Horseback*, details

Elias Ashmole, writing after the Restoration, records that 'where the Pictures of the *Sovereign* or any of the *Knights-Companions* are drawn in Armour, there, even to this day, the George is represented, as fixed at a *Gold Chain*, instead of the *Blue Ribband* and worn about the neck'.[55] In this painting Charles, as Garter Sovereign, has such a gold medallion of St George and the Dragon suspended from a golden chain on his breastplate in precisely the manner described by Ashmole [28a, b].

Charles, of course, inherited his role as Garter Sovereign. As an Order it had been revivified by the Tudors to vie with the Burgundian Golden Fleece and its ceremonies had been redefined during the unsettled period of the Reformation. Under Elizabeth I, the Garter Festival on each St George's Day was deliberately built up as one of the great occasions in the court year when Whitehall was thronged with courtiers and their trains, and the courtyard, through which the great procession of clergy and knights moved, was packed with onlookers who fell on their knees in homage to the Queen. Its aim was to bind those of the highest rank in chivalrous loyalty to the Crown and its policies.[56]

Under Charles I there was a change of emphasis.[57] Charles was less interested in the use of the Garter as a public spectacle and more preoccupied with its religious aspect. This was emphasized by the removal of the festival to Windsor Castle away from London and by the organization of Garter services as patterns of the new

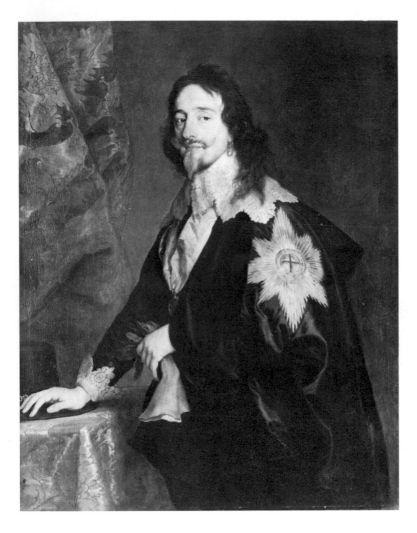

High Church ceremonial so loathed by the Puritans. The king's interest in the Garter is reflected by the order in 1626, a year after his accession, that all knights should wear the Garter badge, the red cross of St George, embroidered on the left side of their cloaks [29]. Soon after, a huge aureole of silver rays was added in emulation of the French Order of the Holy Spirit. Plate too was commissioned for use in St George's, Windsor, and a new splendour marked the festival days. Charles as Garter Sovereign is an apotheosis of the chival-

29. *Charles I wearing the Garter Star, c. 1632-40.* Van Dyck

rous knight, an aspect epitomized in visual form by Rubens's fairy-tale picture of him as St George, the Order's patron, rescuing the princess after having slain the dragon [30].[58]

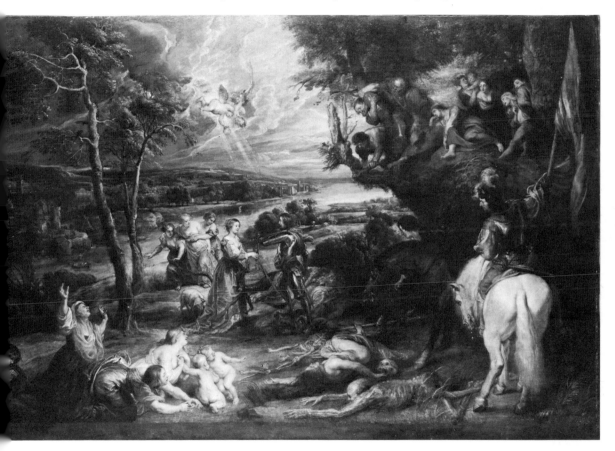

30. *St George and the Dragon*, 1629. Rubens

St George as a saint had come under heavy fire from reforming theologians but found an ardent defender in Peter Heylyn, Bishop of Winchester and prelate of the Order, who published in 1631 his *Historie of that most famous Saint and Souldier of Christ Jesus; George of Cappadocia.* Backed by an overwhelming morass of texts he maintained that St George was 'acknowledged for a saint, before the Popes usurped that lawless power of doing anything in heaven'.[59] The dragon legend was jettisoned, as it already had been in the

Elizabethan period: 'For by the *Dragon* if we understand the Devil, that old malicious *Serpent . . .* and [by] the combat betwixt our blessed Martyr and that Monster, those many snares and baits which by the Devil were provided to intrap him.'[60] The Garter Badge which the king and his fellow knights wear published 'to posterity how bravely he repelled the Devil, how constantly he persevered in the profession of his faith; the whole Church praying with him, and kneeling (like the Virgin) by him, in that holy action, that GOD would give him strength to subdue that enemy, the Dragon.'[61]

The nuances that animated these occasions are captured in an engraving by Richard Cooper after a sketch by Van Dyck for the

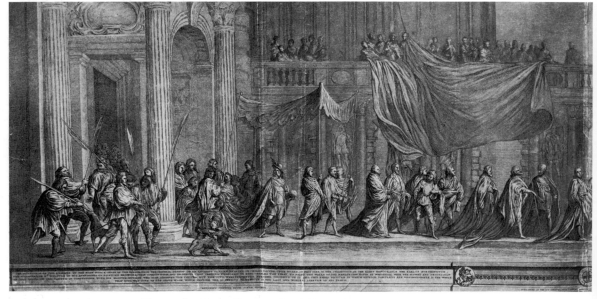

knights going in procession on the Feast Day [31].[62] Elias Ashmole's *History of the Order of the Garter* provides us with no less than three strands of thought which must have run through his mind and those of his contemporaries when they witnessed this sumptuous spectacle:

31. *A Procession of the Knights of the Garter, c.* 1638. Engraving after Van Dyck

'We think it not amiss in speaking of Processions to divide them into military, civil and ecclesiastical: under the military may be

best comprehended Triumphs, and transactions of the Roman Knights; under the civil, the pompous entries of cavalcades of Princes, into or through any great city; and the ecclesiastical are those so generally called wherein the Church proceeds upon a solemn account of supplication or thanksgiving; To all which, in the last place shall follow the order of the Grand procession of this most noble order; which in reference to the degrees of the persons appearing therein is composed of a mixture of such as are in each of the three former . . .'[63]

In other words the procession re-enacts the triumphs of antiquity and fuses secular and ecclesiastical triumph. Van Dyck's sketch does not cover the whole of the procession. On the morning of the feast day the service of the knights was held in the Chapel Royal, in the midst of which the procession took place. In it walked choristers, gentlemen of the Chapel Royal, the verger and prebends of Windsor, the heralds, the officers of the Order, the knights, the Sovereign and gentlemen pensioners. The route was lined by the Yeomen of the Guard and the servants of the knights who held back the crowds. The clergy were glorious in golden copes (the only vestment to survive the Reformation) and the choristers chanted the Litany. The canopy borne over the king was of cloth of gold and his train was borne up by a nobleman of high rank. This was perhaps the only occasion when the Anglican Church could indulge in Baroque Counter-Reformation liturgical splendour, for this was the sole survivor of the old pre-Reformation Catholic procession. Its importance was heightened by the fact that it was unique.

The king in armour on horseback in the National Gallery portrait is therefore sometimes a saint presiding over his knights in prayer, sometimes a warrior leading his troops into battle or sometimes an emperor *à l'antique*, reflecting the new Renaissance classicism as much as Stuart claims to imperial dominion, and yet Van Dyck's Charles I remains coherent as a single monarchical symbol.

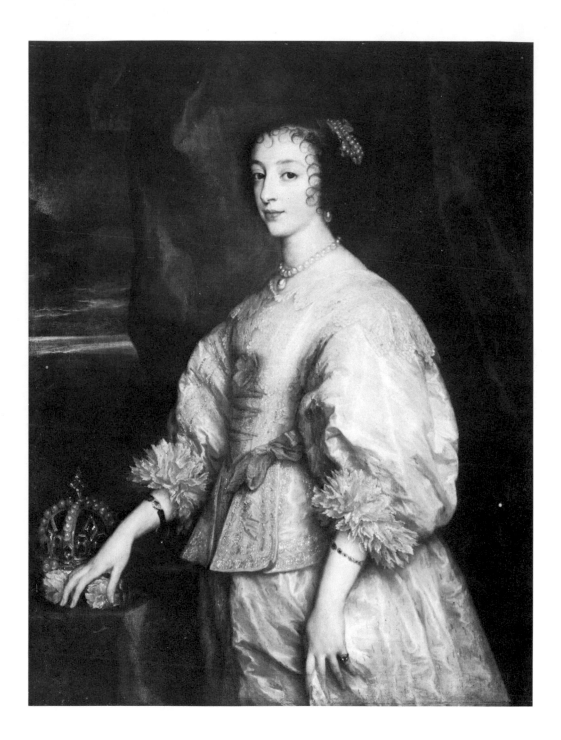

5. Callipolis

We bring Prince Arthur, *or the brave*
 St George *himself, (great Queen!) to you:*
You'll soon discern him; and we have
 A Guy, *a* Beavis, *or some true*
Round-Table Knight, as ever fought
For Lady, to each Beauty brought.

Thomas Carew, *Coelum Britannicum*, 1634

Knights are not only men-at-arms, they are also the suitors and slaves of beauteous ladies. The court of Charles I witnessed an extraordinary revamping of the courtly love tradition, a theme which had found its perfect exposition in Spenser's *Hymn of Heavenly Beauty*, first published over thirty years before. Spenser epitomizes the fusion of the old chivalrous love traditions of knight and lady with the conventions that governed Renaissance Neo-Platonism. Its revival was a deliberate importation affected by the Queen, Henrietta Maria, Henry IV's daughter, who introduced to England the hair-splitting Neo-Platonic love etiquette of the *précieuses* as practised by the adepts of the Hôtel Rambouillet and expounded by that handbook to the whole movement, Honoré d'Urfé's romance *L'Astrée*.[64]

The queen and her circle were very conscious of their importation from beyond the seas. A rudimentary statement of Henrietta Maria's role in introducing the new gentle civilizing influence of Neo-Platonic love is Sir William Davenant's masque *The Temple of Love* performed as part of the Christmas revels of 1635–6. The argument runs as follows: Divine Poesy is sent by Fate to Indamora, Queen of Natsinga (Henrietta Maria) to signify that the time was come, when, by the influence of her beauty – attended by her ladies – the Temple of Chaste Love should be re-established in this Island. The masque deals with the old theme of Blind Cupid, symbol of

32. Henrietta Maria, c. 1632. Van Dyck

illicit sensual love, and Seeing Cupid, the emblem of the higher, purer, spiritual love which the queen and her ladies bring to this isle. Indamora and her train arrive in a maritime chariot and descend to dance their ballets and take part in general revels with the on-lookers:

> *Let then your soft, and nimble feet*
> *Lead and in various figures meet*
> *Those stranger knights, who though they came*
> *Seduc'd at first by false desire,*
> *You'll kindle in their breasts a fire*
> *Shall keep love warm, yet not inflame.*
>
> *At first they wear your beauties' prize,*
> *Now offer willing sacrifice*
> *Unto the virtues of the mind,*
> *And each shall wear, when they depart*
> *A lawful though a loving heart,*
> *And wish you still both strict and kind.*[65]

These verses state in little the attitudes of the cult. The knights who dance with the ladies are at first inflamed by a wrong 'false desire', but are then vanquished to a worship of the 'virtues of the mind'. As James Howell wrote six months earlier: 'The Court affords little news at present, but that there is a Love called Platonic, which much sways there of late: It is a love abstracted from all corporeal gross impressions and sensual appetite.'[66] The knights who dance are subjected by the beauty of the masquers and ascend, through this external loveliness, to a meditation upon the virtues of the mind.

Aurelian Townshend's *Tempe Restored*, which had graced the Shrovetide revels four years before, centres on this belief in which Henrietta Maria descends from the heavens encircled by her ladies as that 'Corporeal Beauty . . . shining in the Queen's Majesty' that 'may draw us to the contemplation of the Beauty of the soul, unto which it hath an Analogy'.[67] Again there is a triumph of Seeing

Cupid through a contemplation by the onlookers of the physical externals of the masquers: 'Corporeal Beauty, consisting in symmetry, colour, and certain unexpressable graces':

> *The Music . . . that ye see, is sweet indeed:*
> *In every Part exact, and full,*
> *From whence there doth an Air proceed,*
> *On which th' Intelligences feed,*
> *Where fair and good, inseparably conjoined,*
> *Create a Cupid, that is never blind.*[68]

As in the *Temple of Love*, the theme is that of the realm of the Divine ideas come down to earth, providing visual material for a Neo-Platonic ascent of the soul. And the queen as Divine Beauty vanquishes the king as personification of 'Heroic Virtue'.

A New Year's gift poem by Thomas Carew presents an unadorned statement on the queen's role as a romantic heroine taming the excesses of the Stuart court by her promotion of the new courtly love:

> *Thou great Commandress, that doest move*
> *Thy Sceptre o'er the Crown of Love,*
> *And throw his Empire, with the Awe*
> *Of Thy chaste beams, dost give Law;*
> *From his profaner Altars we*
> *Turn to adore Thy Deity.*
> *He only can wild lust provoke;*
> *Thou, those impurer flames can'st choke;*
> *And where he scatters looser fires*
> *Thou turn'st them into chaste desires.*[69]

It is such a mood that invests Van Dyck's many portraits of the queen [32], in which he presents us with an image, in Waller's words 'occasioned upon the sight of Her Majesty's picture', of Henrietta Maria both as 'Queen of Britain, and Queen of Love'.[70]

This revamped Neo-Platonism accounts too for most of Van Dyck's treatment of court ladies. Waller's tribute to Van Dyck's role in purveying in portrait form the images of courtly love in the same way that Inigo Jones provided them on the stage, sums up how Cavaliers looked at the painter's renderings of the reigning beauties of the day:

> *The heedless lover does not know*
> *Whose eyes they are that wound him so;*
> *But, confounded with thy art,*
> *Inquires her name that has his heart.*
>
> *Strange! that thy hand should not inspire*
> *The beauty only, but the fire;*
> *Not the form alone, and grace,*
> *But act, and power, of a face.*[71]

In the highly Neo-Platonized court of Charles I the painted images of Van Dyck assumed an extra importance and 'power'.

Neo-Platonism also explains Van Dyck's ravishing canvas of Cupid discovering Psyche in the 'dull lethargy' of sleep [33].[72] The court preoccupation with the Cupid and Psyche myth is explicable entirely in the context of Renaissance Neo-Platonism where the story is glossed in terms of a Neo-Platonic ascent of the soul inspired by a vision of divine beauty.[73] This particular picture was possibly commissioned in connection with a project to decorate the queen's cabinet at Greenwich. During the troubled spring and summer of 1640 negotiations were under way with Jacob Jordaens via Balthazar Gerbier for a series of twenty-two canvases on this theme for Greenwich. If these had been installed they would have provided in permanent form the motivation of masque after masque danced by the queen and her ladies.[74]

At the close of *The Temple of Love* the enthroned king and queen contemplated a vision of the Temple of Chaste Love, to which Chaste Cupid descends in carnation and white and, joining the

33. *Cupid and Psyche*, c. 1639-40. Van Dyck

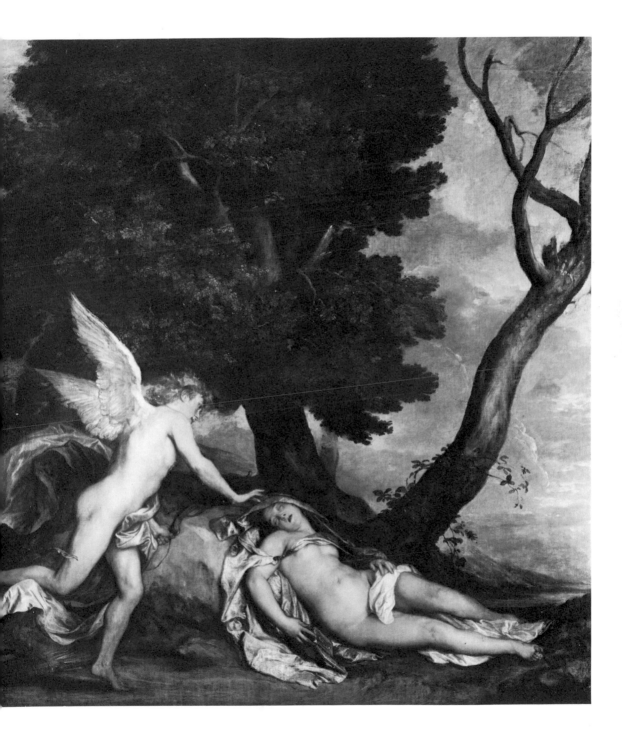

chorus of singers disguised as poets led by Orpheus, marches up to the enthroned couple singing:

> *Whilst by a mixture thus made one,*
> *Y'are th'emblem of my Deity,*
> *And now you may, in yonder throne,*
> *The pattern of your union see.*[75]

While the queen reigns as the subject of a love cult, the blissful royal marriage and her ever fruitful womb are exalted almost to the level of a state philosophy. Charles and Henrietta are the first English royal couple to be glorified as husband and wife in the domestic sense. Daniel Mytens celebrates this idyll of knight and

34. *Charles I and Henrietta Maria depart for the chase,* c. 1630-32. Daniel Mytens

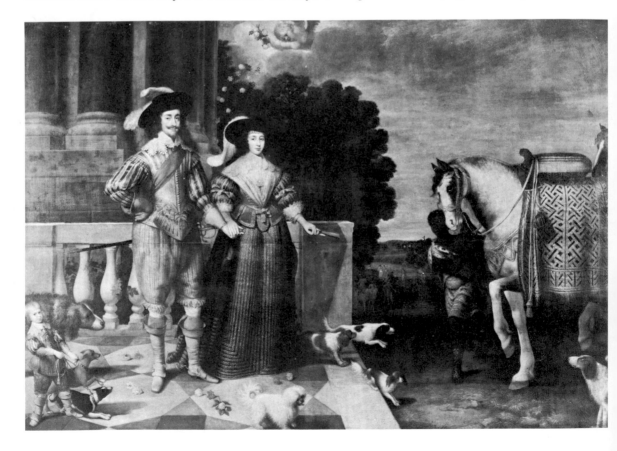

lady in the picture in which the royal couple leave for the chase, a putto showering them with roses, the flowers of Venus [34].[76]

This is a crude statement in comparison with the witty urbanity that Ben Jonson could lavish on such a theme. *Loves Welcome at Bolsover*, written for the entertainment of their majesties in the summer of 1634, is a celebration of the virtues of the royal couple within the context of courtly Neo-Platonism.[77] It consisted of a chorus sung while they banqueted, a comic speech by Colonel Vitruvius and his men, a deliberate tilt at Ben's old colleague and now hated rival, Inigo Jones, a dialogue between Eros and Anteros and a speech by one Philanthes. The chorus during the first banquet makes the initial statement on mutual love and its nature:

> *If Love be call'd a lifting of the Sense*
> *To a knowledge of that pure intelligence*
> *Wherein the Soul hath rest, and residence . . .*[78]

The senses are then listed in a descending order as categorized by Ficino: sight, hearing, smell, touch and taste. Jonson is opening the entertainment by explaining that the starting point is the contemplation of the beautiful through which one ascends to a contemplation of 'that pure intelligence'. Love works through the senses, orders and transcends them, lifts them to a knowledge of the divine:

> *Love is a Circle, both the first, and last*
> *Of all our actions, and his knot's too fast*
> *A true-love Knot, will hardly be untied,*
> *And if it could, who would this Pair divide?*[79]

Mutual love is a perfect circle which consumes itself, and the love of the king for the queen is one of many circles of love binding the cosmos, the love of God for the world and of man for God. Jonson's argument is developed by the dialogue which follows later between Eros and Anteros, which re-states the theme of mutual love under allegorical guise, Eros or Cupid having to have a brother because love by its very nature 'increaseth mutually'. This in its turn is

applied to Charles I and Henrietta Maria in a final speech which describes what might almost be an allegorical portrait of the couple, Fortune and Time fettered at their feet and the Fates spinning a thread around them.

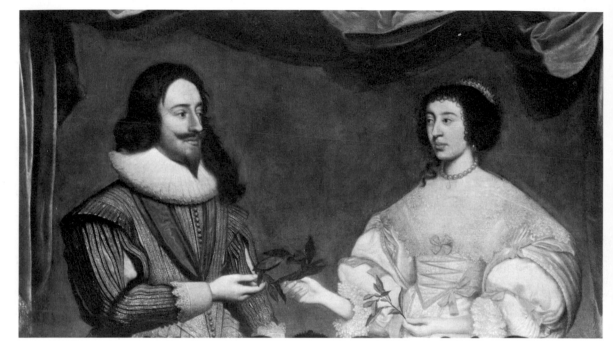

In another attempt, attributed to Mytens, to depict the royal couple Henrietta Maria is shown presenting her husband with the victor's laurels while she holds the olive of peace [35]. The popularity of the theme is reflected in Charles's commission for Van Dyck to paint his own version [36].[80] Such a picture is incomprehensible unless seen as part of the fabric of Neo-Platonic romance spun around their relationship as knight and lady. Even in the midst of the Civil War Herrick curses those who dare part such an ideal couple:

35. *Charles I and Henrietta Maria*, *c.* 1630–32. Attributed to Daniel Mytens

36 (*opposite*). *Charles I and Henrietta Maria*, *c.* 1632. Van Dyck

> *Woe, woe to them who (by a ball of strife)*
> *Do, and have parted here a Man and Wife:*

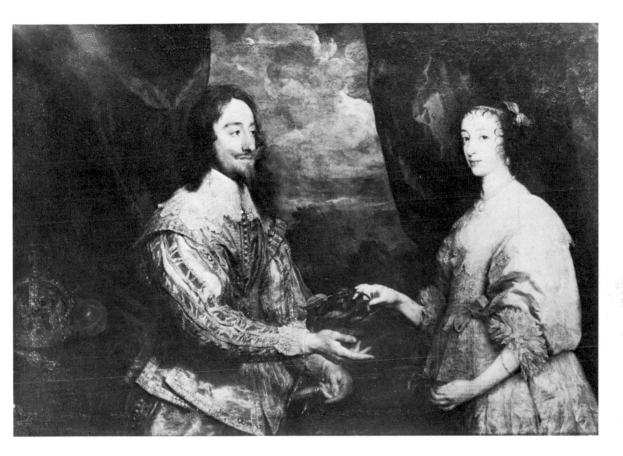

Charles the best Husband, while Maria strives
To be, and is, the very best of Wives . . .[81]

The king, clasping the hero's laurels, is seen in the role he so often assumed in the masques, that of the heroic lover. In Jonson's *Love's Triumph through Callipolis* (1631) he arrives with fourteen other lovers escorted by Cupids as torchbearers seeking admission to Callipolis, 'the City of Beauty and Goodness':

Where love is mutual, still
All things in order move
The circle of the will
Is the true sphere of Love.[82]

The masques contain the most coherent statements of this theme as year after year Charles's role is sustained and elaborated as the warrior knight laid low by the beauty of the queen. This aspect belongs too to our equestrian portrait of Charles as the warrior prince, for although Henrietta Maria is not present his role as the knight was always a celebration of the idyllic love of the king for his queen. In Aurelian Townshend's *Albion's Triumph* (1632) he appears as an Ancient British king triumphing through his capital city, Albipolis. Again Ancient British architecture is seen as having been in the classical style. Albipolis is the chief city of Albion, the name the Trojans gave to Britain, and at the climax Charles, dressed as a Roman Emperor, is revealed standing in front of a temple attended by his consuls. These are vanquished by Diana and Cupid, Chastity and Love, who shoot arrows at them. Charles is described as glorious and heroic and his queen, Alba, as all purity and whiteness. Then king and masquers descend, 'conquered by her eyes', to offer 'Love's sacrifice'.

Thomas Carew's *Coelum Britannicum* (1634) again goes through these motions. Once more the king and masquers are Ancient British, once more there is a city, this time ruined, of classical Ancient British ruins and yet again the 'mighty British Hercules' descends to 'the shrine of Beauty'. Both Charles I and Henrietta Maria, casting themselves in these roles of knight and lady, lived out, amidst a blaze of publicity, a romantic saga that stretched over the years of Personal Rule down to the outbreak of Civil War.

37. Design for *The Shepherd's Paradise*, 1633. Inigo Jones

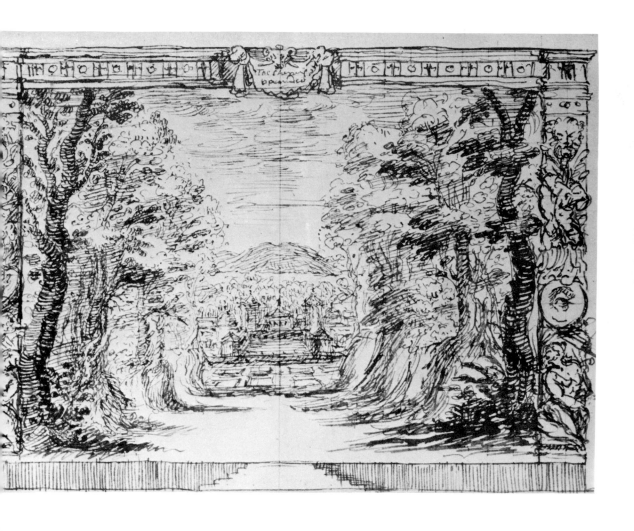

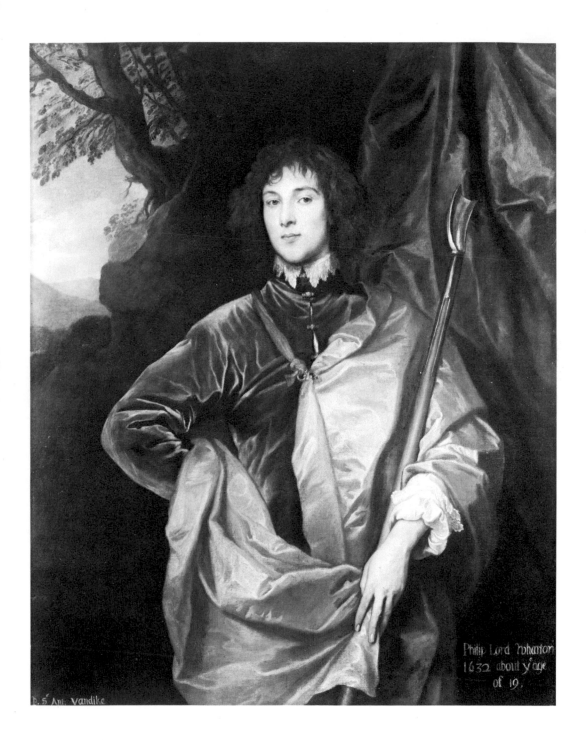

Philip Lord Wharton
1632 about y^e age
of 19.

P. S^r Ant: Vandike

6. A Well-wrought Landscape

There is not in my opinion in all the art of painting such variety of delectable colours, nor can the eye be so richly feasted as with the prospect of a well-wrought landscape.

Edward Norgate, *Miniatura*, 1625

CELADON

38 (*left*). *Lord Wharton*, 1632. Van Dyck

39 (*above*). Detail from title page for Honoré d'Urfé's *Astrée*, Paris, 1615

If courtly Neo-Platonism could find expression in antique myth, it could also equally find one in the pastoral. The queen's Neo-Platonic preciosity imported too the vogue for interminable pastoral dramas in which the court found a vehicle for patterns of behaviour and discourse in a dramatic realization of their dream world.[83] Walter Montagu's *The Shepherd's Paradise*, staged at Somerset House in 1633 and acted by the queen and her ladies, was the most outright and long-winded exposition of this Neo-Platonic arcadia [37]. During the remainder of the thirties, the court was supplied with endless variants of this material based ultimately on tales of the Greek decadence, by Heliodorus, Tatius and Longus. Van Dyck's portrait of Lord Wharton as a shepherd clutching an *houette* [38] is an overt reference to this world and he may be compared with the shepherd on the title page of part I of *Astrée* [39]. But Van Dyck's references are usually more oblique, in the trailing trees, fountains, nebulous rock formations and twilights with which he encircles his English sitters.

There is an ambivalence in the artist's treatment of landscape for although he is able to place court ladies in Arcadia he could at the same time be quite specific in his rendering of the English countryside. Charles I rides the dun horse in an English oak forest even though the trees are rendered in a Titianesque manner. It is a gently rolling countryside with great trees and clumps on hillocks. A signed drawing probably of 1634 [40] is one of a group of sketches by Van Dyck of this sort, the foliage of the trees seeming to flutter downwards towards the two cottages that stand in the hollow beneath.[84] Charles, in the National Gallery portrait, is painted amidst

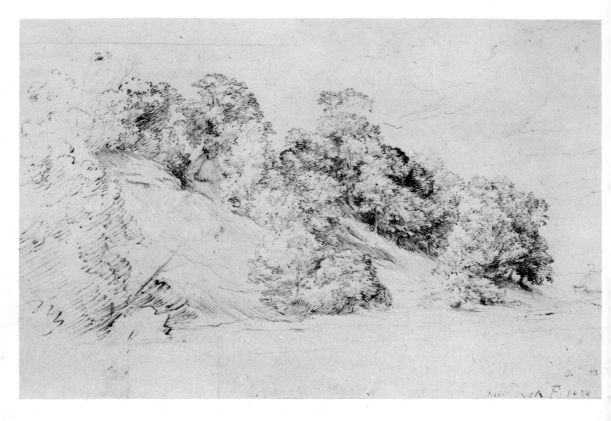

a naturalistic landscape of the country over which he rules which is, at the same time, idealized [41]. There is also a touch of the bucolic vision as seen through the eyes of the country pastoral so often evoked by the Cavalier poets. In Milton's *Arcades*, an alfresco fête performed in honour of the Countess of Derby, the Genius of the Wood appears:

40 (*above*). *Trees on a Hillside*, 1634. Van Dyck

41 (*right*). *Charles I on Horseback*, detail

> *. . . I am the power*
> *Of this fair Wood, and live in Oak'n bower,*
> *To nurse the Saplings tall, and curl the grove*
> *With ringlets quaint, and wanton windings wove.*
> *And all my Plants I save from nightly ill,*
> *Of noisome winds, and blasting vapours chill.*
> *And from the Boughs brush off the evil dew,*

And heal the harms of thwarting thunder blew,
Or what the cross dire-looking Planet smites,
Or hurtful Worm with canker'd venom bites.
When Ev'ning grey doth rise, I fetch my round
Over the mount, and all this hallow'd ground,
And early ere the odorous breath of morn
Awakes the slumbering leaves, or tasselled horn
Shakes the high thicket, haste I all about,
Number my ranks, and visit every sprout
With puissant words, and murmurs made to bless . . .[85]

Here, mixing standard *topoi* with direct observation from nature in his usual way, Milton delineates the naturalistic details of a wood in the same way as it is depicted in our picture which is yet also arcadian.

The whole concept of landscape was still a relatively new one to the Stuart court and the landscape paintings they loved most were Flemish and North Italian.[86] Charles I's collection contained ample instances for Van Dyck to copy of the rich landscapes of the Venetians, pictures by Titian, Tintoretto, Veronese and the Bassani. But although the handling of the paint and colouring shows the inspiration of these painters the compositional formula, in which a vast tree frames one side of the picture, is Flemish. Van Dyck used this formula a number of times as in *Charles I à la ciasse* [25], in his *Cupid and Psyche* [33] and in the shepherd, *Lord Wharton* [38].

Although the equestrian portrait is not specifically *à la chasse* it does belong to a long series of portraits which directly or indirectly depict members of the Stuart family *à la chasse*. It is at least worth mentioning the thought-permutations that could be extracted by such a person as Ben Jonson out of the vision of a monarch on horse-back enjoying the pleasures of the hunt.[87] Almost twenty years before the equestrian portrait was painted Charles, then Prince of Wales, danced in Jonson's *Time Vindicated* in which the theme of youths hunting amidst the forest was developed into an image of

virtuous discipline in service of the Crown. The masquers as the Glories of Time dance the revels which end by them being summoned back to the scene of a wood by Diana. She explains that the place of both Prince and courtiers is not in courtly dalliance but in serious activity personified in the exercise of the chase:

> *Hunting it is the noblest exercise,*
> *Makes men laborious, active, wise,*
> *Brings health, and doth the spirits delight,*
> *It helps the hearing, and the sight:*
> *It teacheth arts that never slip*
> *The memory, good horsemanship,*
> *Search, sharpness, courage, and defence,*
> *And chaseth all ill habits thence.*[88]

Hunting does not only develop the virtues of the hunter, its end is to kill vices:

> *Turn hunters then*
> *Again,*
> *But not of man.*
> *Follow his example*
> *And just example*
> *That hates all chase of malice and of blood,*
> *And studies only ways of good*
> *To keep soft Peace in breath.*
> *Man should not hunt mankind to death,*
> *But strike the enemies of man;*
> *Kill vices if you can:*
> *They are your wildest beasts.*
> *And when they thickest fall, you make the gods true feasts.*[89]

In this case the masquers are to follow the example of the onlooking king, James I, in subjecting vices and pursuing 'soft Peace'. The idea of the king as the hunter vanquishing vices is yet another permutation of the king as St George defeating 'that old malicious serpent'.

42. *Minerva protects Pax from Mars*, 1629. Rubens

7. Philogenes

. . . let us, that in myrtle bowers sit
Under secure shades, use the benefit
Of peace and plenty, which the blessed hand
Of our good King, gives this obdurate Land;
Let us of Revels sing . . .

Thomas Carew, *An Elegy on the Death*
of the King of Sweden, 1632[90]

Van Dyck's visions of the king all relate to the years of Charles's Personal Rule, those eleven years between 1629–40 in which he ruled without Parliament, later to be denounced by his opponents as the Eleven Years Tyranny. In March 1629 Parliament was dissolved never to reassemble until the unhappy months of 1640. At home, efforts were made to revivify and expand the old crumbling Tudor administrative machinery. A brilliant statesman emerged in Thomas Wentworth, Lord Strafford, who imposed order in the north and in Ireland, and a relentless cleric in Archbishop Laud, who set about the overhaul and unification of the strange series of misalliances that made up the Church of England. To understand *Charles I on Horseback*, which is a quintessential artistic expression of this decade, it is necessary to forget totally what happened after 1640 and to ignore, for the most part, Puritan opposition attitudes during the 1630s, visualizing, as far as possible, these years through the unrealistic eyes of an optimistic court who believed in and built up the myth of a Monarch by Divine Right.

On 16 September 1629 peace was sworn with France; three months later, on 15 December, peace with Spain. Thenceforward peace is the crucial theme of all courtly paeans whether it is Rubens's lustrous canvas on the theme of Peace [42], Richard Fanshawe's hymn to 'White Peace (the beautiful'st of things)' in his translation of Guarini's *Il Pastor Fido* or Thomas Carew's exhortation to 'Circle with peaceful olive boughs . . . his Regal

brows'. Every court masque for the decade ends with a tableau either directly or indirectly on the theme of peace. Townshend's *Albion's Triumph* performed in 1632 closes with a vision of Whitehall Palace, Peace descending from the heavens flanked by Innocence, Justice, Religion, Affection to the Country and Concord, arriving on earth to be greeted by the gods of plenty.[91] Even abroad England was seen in these terms, for a masque in Prague to honour the Earl of Arundel's abortive mission to the Emperor in 1636 showed Peace finding her haven in England while Mars and Vulcan, the personifications of the horrors of the Thirty Years War, reigned over the mainland of Europe.[92]

The theme is found in its most defiant form in James Shirley's *Triumph of Peace* staged in 1634 in answer to Prynne's puritanical denunciation of court stage frivolities. In this the masquers come as the sons of Peace and the opening scene is the piazza of Peace. Later in the masque Peace appears in the heavens banishing the anti-masquers, the profane as she calls them. Peace brings in her train Law; the arrival of these two leads to the descent of the maiden Justice or Astraea. These deities, attended by a great train of musicians, sing an ode to Charles and Henrietta:

> *To you great king and queen, whose smile*
> *Doth scatter blessings through this isle,*
> > *To make it best*
> > *And wonder of the rest,*
> *We pay the duty of our birth;*
> *Proud to wait upon that earth*
> > *Whereon you move*
> > *Which shall be nam'd*
> *And by your chaste embraces fam'd,*
> > *The paradise of love.*[93]

In this the theme of political peace is related to the web of Neo-Platonic romance woven around the couple. The sixteen masquers, attired *à l'antique*, were presented as the sons of Peace, Law and

Justice, 'The children of your reign'. The theme is that of an earthly Olympus replacing a heavenly, an identification specified by Justice:

> *My eyes are blest again, and now I see*
> *The parents of us three :*
> *'Tis Jove and Themis forward move,*
> *And sing to Themis, and to Jove.*[94]

Themis and Jove are Henrietta Maria and Charles I. Peace, Law and Justice are the daughters of Themis and Jove. The royal pair had set before them a statement on the fruits of their rule.

The final, almost hysterical, statement of this is Davenant's *Salmacida Spolia*, the last of the great masques to be staged before the Civil War.[95] It was performed on 21 January 1640; nine months later the Long Parliament met. Both king and queen acted in it, this being made possible by the presence of Henrietta Maria's mother, Marie de' Medici, to whom the reverences to the state could initially be addressed. The theme of the masque was 'that his Majesty out of his mercy and clemency . . . seeks all means by which to reduce

43. Design for scene II of *Salmacida Spolia*, 1640. Inigo Jones

44 (*left*). Costume design
for Charles I as Philogenes, 1640.
Inigo Jones

45 (*right*). Design for final scene
of *Salmacida Spolia*, 1640. John Webb

tempestuous and turbulent natures into a sweet calm of civil con-
cord'. It opens with the furies in the midst of a storm who spurn
the king's peace, but the scene changes to a vision of rural England
in all her fruitfulness and Concord and the Genius of Great Britain
descend in a silver chariot through the clouds lamenting those who

spurn the wisdom of the king, the 'wise Philogenes' [43]. Charles [44], who has heroically trodden the rocky pathway to the throne of honour, is discovered attended by his masquing companions, seated in a chair of gold, bound captives at his feet. Soon after, the queen and her ladies float downwards on a cloud to join them and jointly they dance their ballets. The real crux came in the final tableau watched by the assembled court. The scene changed to a great and

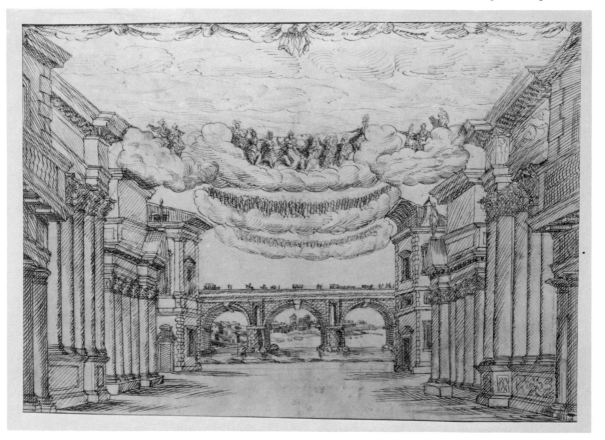

prosperous city [45]. From the heavens the eight spheres came down and two other great clouds full of musicians and beyond them in the distance opened a vista to infinity of gods and goddesses. In the words of Davenant this 'filled all the whole scene with apparitions and harmony'.

So musical as to all ears
Doth seem the music of the spheres,
Are you unto each other still;
Turning your thoughts to either's will.

All that are harsh, all that are rude,
Are by your harmony subdu'd;
Yet so into obedience wrought,
As if not forc'd to it, but taught.[96]

The love of the king for the queen is mirrored in the love for his people, which in turn mirrors that heavenly love that binds the whole cosmos in universal harmony. If one believed, as those who watched the Stuart masques did, in that complex series of correspondences that governed the universe, spectacles such as this were stating eternal, immutable, truths on royalty by peopling the stage with a succession of tableaux of the Divine Ideas of which the court itself was but the earthly reflection.

How can this myth of *pax* hammered out by every court eulogist for a decade be reconciled with our painting of the king as a warrior on horseback? Once again the masques provide an answer. The king is always the knightly hero who, subjected by the queen as the perfect chivalrous heroine, brings peace and other blessings showering upon this island. It is an essay on a favourite Renaissance theme, *concordia discors*, harmony achieved through the conjunction of opposites. After the dénouement of the encounter of king and queen in allegorical guise as personifications of 'opposite' virtues the masques nearly all proceed to a series of set stage pictures on *pax*. Its most sophisticated poetic exposition is Sir John Denham's *Cooper's Hill*, in which Windsor Hill symbolizes Royalist politico-religious harmony arising from a proper tension within the king as God's viceroy of strength and beauty, war and religion, severity and kindness. In the poem Charles and Henrietta Maria are cast as Mars and Venus and the offspring of this warrior prince and his goddess of love is *Harmonia*.[97]

8. A Little God

. . . you are a little GOD to sit on his throne, and rule over other men.

<div align="right">James I, Basilikon Doron, 1599</div>

If one had to pick a single work whereby to explain our and other Van Dyck portraits of Charles I – and indeed much of the motivation of the arts at court during the first four decades of the seventeenth century – it would be the *Basilikon Doron* in which the king's father, James I, laid down his creed of Monarchy by Divine Right.[98]

The burden of this advice, written for his eldest son Prince Henry, is summed up in the opening lines of the sonnet placed at the very beginning:

> *God gives not kings the style of Gods in vain,*
> *For on his throne his Sceptre do they sway . . .*[99]

James's speech to Parliament on 21 March 1609 usefully sums up in miniature the arguments he labours at length in the *Basilikon* for the divine sanctions that surround a sovereign:

'The state of Monarchy is the supremest thing upon earth: for Kings are not only God's lieutenants, and sit upon God's throne, but even by God himself they are called Gods. There be three principal similitudes that illustrate the state of Monarchy: one taken out of the word of God; and the two other out of the grounds of Policy and Philosophy. In the Scriptures Kings are called Gods, and so their power after a certain relation compared to the Divine power. Kings are compared to Fathers of families: for a King is trewly *Parens patriae*, the politique father of his people. And lastly, Kings are compared to the head of this Microcosm of the body of man.'[100]

Bearing these ideas in mind every image of Charles I, including all the Van Dyck portraits, is a representation of 'a little God'.

There is no fully-fledged Caroline exposition of the Monarch by Divine Right. The portraits, allegorical paintings, poetic tributes, dedications, court ceremonies and masques do, however, propagate a coherent and consistent image. If it belongs to anything it is to the *speculum principis* tradition, those mirrors which list the virtues that the ideal prince should have: justice, mercy, temperance, prudence, moderation, chastity, diligence, courage, piety and wisdom. By attaining and practising these virtues peace and plenty will follow and Fame will sing their praises in eternity. During the Renaissance, under the impact of optimistic humanism, this tradition was transmuted. Through the stress given to classical examples of the virtues the old medieval Christian framework was weakened and the picture of the prince that emerges is expansive and humanistic, a prince more akin to the perfect *cortegiano*, although his sphere of activity is different.

In the early seventeenth century the mood again shifts. We can find this exemplified in France in Balzac's *Le Prince*, the first volume of which appeared in 1631.[101] To the writers of Renaissance mirrors of princes the great rulers of antiquity possessed virtues to which contemporary rulers should aspire. Balzac jettisons this. 'It is no longer necessary', he writes, 'to look for the ideal Prince in the Cyropaedia, nor run to Rome to admire statues of Consuls and Emperors, nor praise the dead to the detriment of the living. There is not one ancient in all this people of stone and bronze who is the equal of our Hero [i.e. King Louis XIII]. We possess what our forefathers longed for; nor could we bring to mind anything to equal what we see before our eyes.'[102] Virtues are not held up to Louis XIII for imitation, he *is* the personification of them, every act of his is an exemplification of one or other of his divine gifts.

Has not the same process happened in England? Is this not what the poetry of Carew, Herrick, Waller, and Crashaw, the masques of Jonson, Townshend, Shirley and Carew, the canvases of Mytens and Van Dyck are saying? Charles is not incited to virtue and imitation. He *is* the personification of all the virtues both as a ruler and as

a gentleman. To refer back to the last of the masques: Charles *is*, Davenant states, that 'secret Wisdom' who 'will change all . . . malicious hope of these disorders into sudden calm'[103] and 'out of his mercy and clemency' will establish civil concord.[104] Even the queen comes from the heavens as a reward of *his* prudence and the king is discovered on the throne of Honour. The song sung by the beloved people on beholding their ruler at this moment hymns him as the living embodiment of wisdom, mercy, valour, clemency:

> *Since strength of virtues gain'd you Honour's throne,*
> *Accept our wonder, and enjoy our praise!*
> *He's fit to govern there, and rule alone,*
> *When inward helps, and not outward force doth raise.*[105]

46. *The Liberal Arts and Sciences,*
after 1626. Orazio Gentileschi

Inigo Jones makes an even more explicit statement in his commentary to *Tempe Restored*: 'in Heroic Virtue is figured the King's Majesty who therein transcends as far common man as they are above Beasts, he truly being the prototype to all the Kingdoms under his Monarchy, of Religion, Justice, and all the Virtues joined together.'[106] Townshend reminds us here that under the Stuarts the politico-religious position of a Monarch by Divine Right fuses with the Renaissance concept of the hero who, as defined in the *locus classicus*, Book VII of the *Nicomachean Ethics*, is superhuman, godlike and divine in the superabundance of his virtues.[107] The shift is from the complex glorification typical of the Tudors to a concrete deification of the Stuarts. If, as Charles's father argued, kings were 'little gods' on earth, the coda was that the attributes of God should be applied to them and in a way they were.

The philosophy which governed the arts at the Cavalier court was to make manifest and articulate the lustre and influence of the king. It made up a continuous celebration, in painting, poetry, music and the dance, of the glory and virtues of the wearer of the British Crown. This is one aspect of the Baroque Monarch as Maecenas whether celebrated by Gentileschi in his ceiling paintings for the Queen's House at Greenwich [46] depicting the arts and sciences in a swirl of homage[108] or by the vision at the end of the queen's masque of *Chloridia* (1631) in which Fame ascends flanked by Poesy, History, Architecture and Sculpture:

> *We sustain thee, learned Poesy*
> *And I, her sister, severe History,*
> *With Architecture, who will raise thee high,*
> *And Sculpture that can keep thee from to die;*
> *All help to lift thee to eternity.*[109]

Honthorst makes the same statement in his group portrait of Charles I and Henrietta Maria as Apollo and Diana seated in the clouds receiving the Duke of Buckingham who, as Mercury, presents to them the Liberal Arts [47]. And Davenant's masque *Lumina-*

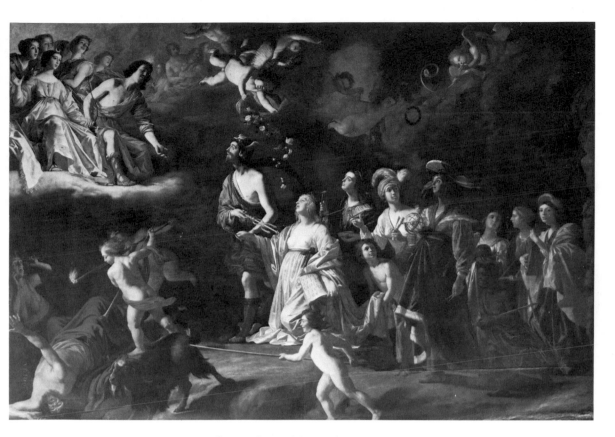

*47. Buckingham presents
the Liberal Arts to Charles I
and Henrietta Maria,
1628. Gerard van Honthorst*

lia, performed in 1638, tells the same story but in dramatic form of how the Muses and their priests, driven out of Greece by the fierce Thracians, and 'out of Italy by the barbarous Goths and Vandals', find refuge in Britain 'by the unanimous and magnificent vertues of the King and Queenes Majesties making this happy Island a pattern to all nations, as *Greece* was amongst the *Ancients*'.[110]

But the arts did not only glorify and acclaim, they were also seen as contributing in a specific sense to the establishment of virtuous discipline and order in the realm. The rule of the God-King emanating his virtues down through the descending hierarchy of a heaven-ordained society was laid down by Charles's father:

'Remember then, that this glistring worldly glory of kings, is given them by God, to teach them to press so to glister and shine

before their people, in all works of sanctification and righteousness, that their persons as bright lamps of godliness and virtue, may, going in and out before their people, give light to all their steps.'[111]

It is as such bright lamps of godliness and virtue that we see Charles and Henrietta deployed by the artists and writers at court for, as Sir William Davenant wrote, 'the most effectual Schools of Morality are Courts and Camps'.[112] Davenant is important for this transference of the political beliefs of James I to the poetic mode of the Caroline court. In speaking of heroic poetry in his preface to *Gondibert* he writes that 'if the examples it presents prevail upon their Chiefs, the delight of Imitation . . . will rectify by the rules which those Chiefs establish of their own lives, the lives of all that behold them . . .'[113] Hobbes in his reply to the Preface is even more succinct: 'For there is in Princes and men of conspicuous power, (anciently called *Heroes*) a lustre and influence upon the rest of men resembling that of the Heavens . . .'[114]

Davenant's own masques are a perfect exposition of this belief in which Charles I, assisted by emanations of his own moral and intellectual virtues, triumphs over his enemies. *Britannia Triumphans* and *Salmacida Spolia* were both designed to achieve this semi-magical end by exhibiting the King-Hero to his chiefs, thus rectifying through them, to use Davenant's words, 'the lives of all that behold them'. The control of the visual exhibition of the king to his subjects on the stage was but a more vivid extension of the display of his painted image by Van Dyck and his contemporaries. Surely the end of Van Dyck's portraiture too was to distil the Divine Idea of Monarchy on to canvas and so also to rectify 'the lives of all that behold them'.

9. Epilogue: Divinist Melancholy

But hail thou goddess, sage and holy,
Hail divinist melancholy. . . .

Milton, *Il Penseroso, c.* 1632

The reader may well feel at this point somewhat confused as to the endless meanings that can be extracted out of what may at first glance seem little more than a picture of a king on horseback standing beneath a tree. It would be ridiculous to suppose that all these complicated nuances were listed off on a piece of paper and handed to Van Dyck to incorporate somehow into *Charles I on Horseback.* That would be too crude. In this essay I have tried to uncover the several layers of meaning, explicit and implicit, contained in this single portrait, to unfold some of the complex interactions of image and idea, by evoking in the mind of the mid twentieth-century onlooker the thought patterns prevalent at the Cavalier Court in the 1630s. Only by doing this can we begin fully to understand the rich layers of allusion Van Dyck incorporated in his great portrait.

Finally however we must come back to where we began. Why does Charles I have this look of languorous sadness in his portraits? He undoubtedly does, which might be explained by the simple fact that he actually looked like that. But this we know not to be altogether true from the evidence of other paintings by Mytens or Pot for instance. Van Dyck deliberately heightens the sad grandeur. Charles's eyes are lustrous but heavy-lidded and there is a far-away look. His hair falls on either side of his face with a studied negligence. His features are refined so that they suggest the preciosity of an aesthete. What has been read at a later date as a premonition of impending doom must surely be Van Dyck's way of subtly introducing that most fashionable of Caroline moods, that of shadowed melancholy.

At first glance this may seem a very strange idea that a monarch celebrated as *imperator*, knight, lover, hero and god should be all

these things and yet be invested by an overall mood of pensive gloom. But melancholy of the right kind was, in the seventeenth century, an attribute of men above all others 'most witty, which causeth many times divine ravishment, and a kind of *enthusiamus . . .* which stirreth them up to be excellent Philosophers, Poets, Prophets, &c.' This divine gift is not, of course, in any way to be confused with the 'melancholy madness' which Burton also discusses.[115] This in contrast is the *melancholia* of the Florentine Neo-Platonic philosopher Marsilio Ficino whose book *De Vita Libri Tres* sums up the Renaissance revival of the Aristotelian concept of melancholy as the hallmark of all those 'who have become eminent in philosophy, or politics or poetry or the arts'.[116] The fashionable attributes of this became all the rage in late Elizabethan England when young gallants sauntered around negligently dressed in black, seeking the solace of the greenwood tree for meditation. Our equestrian portrait has a touch of this dignified melancholy. Charles is solitary and removed in mood; he is engrossed in an aura of contemplation in the midst of a shady wood. The mysterious joys of Milton's Goddess in *Il Penseroso* are there. Melancholy is a lady sober and stately, sage and holy, who rewards her votaries with the pleasure of solitary meditation. She treads

> *With even step and musing gait,*
> *And looks commercing with the skies.*[117]

Her devotees are scholars and lovers of the arts. They will be guided

> *To arched walks of twilight groves*
> *And shadows brown that Sylvan loves*
> *Of Pine, or monumental Oak,*
> *Where the rude Axe with heaved stroke,*
> *Was never heard the Nymphs to daunt . . .*[118]

And through her rites they will ascend to a contemplation of divine truth. For that most pious of kings, Charles I, the choice of this mood of calm spiritual contemplation was undoubtedly Van Dyck's master stroke.

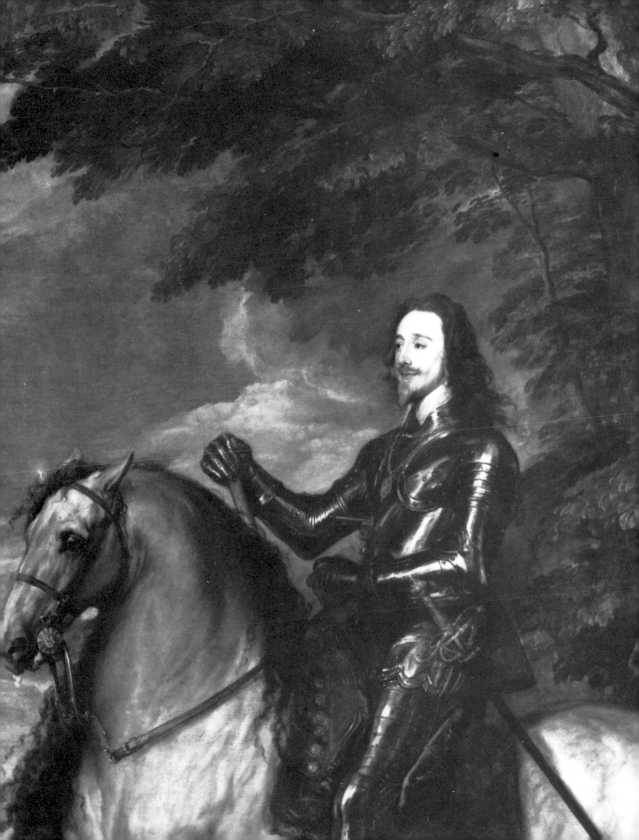

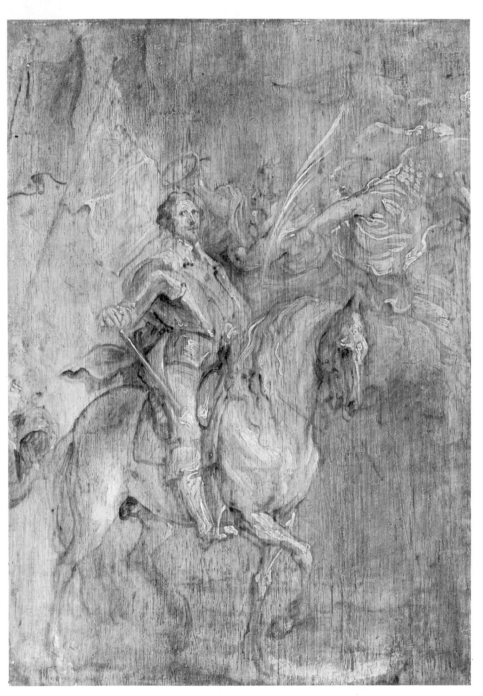

49. Sketch for an
equestrian portrait, *c.*
Van Dyck

Notes

1. Two brief surveys of Van Dyck and Charles I are: David Piper, 'Portraits of Charles I' in *King Charles I*, Historical Association, 1949, pp. 23–8; O. Millar, *Catalogue of Tudor, Stuart and Early Georgian Pictures in the Collection of H.M. the Queen*, London, 1963, I, pp. 16–20. A book on *Charles I on Horseback* tackles none of the problems essayed in this present study: Margaret Goldsmith, *The Wandering Portrait*, London, 1954.

2. See Roy Strong, *The English Icon: Elizabethan and Jacobean Portraiture*, London & New York, 1969, p. 250 (230); on the early portraiture of Charles I see Margaret R. Toynbee, 'Some Early Portraits of Charles I', *Burlington Magazine*, XCI, 1949, pp. 4–9, & O. Millar, 'Charles I', in ibid., p. 86.

3. The most useful accounts of his English period are: W. Hookham Carpenter, *Pictorial Notices of Sir Anthony van Dyck*, London, 1844; Lionel Cust, *Anthony van Dyck*, London, 1900; E. K. Waterhouse, *Painting in Britain 1530 to 1790*, London, 1953, pp. 46–51; M. Whinney and O. Millar, *English Art 1625–1714*, Oxford, 1957, pp. 67–74; H. Gerson and E. Ter Kuile, *Art and Architecture in Belgium 1600–1800*, London, 1960, pp. 109–26.

4. All the available documentation is in Gregory Martin, *National Gallery Catalogue: Flemish School*, 1970, pp. 41–7.

5. This is the opinion of Martin, op. cit., p. 42. For the opposing view see O. Millar, *Catalogue*, I, p. 94 (II, 144). For the role of the Wilton grisaille sketch [49], probably of Prince Thomas of Savoy, see Martin, p. 43.

6. D. S. Bland, 'The Barriers', *Guildhall Miscellany*, I, 1952–9, No. 6, pp. 7–14; *The Letters of John Chamberlain*, ed. N. E. McClure, Philadelphia, 1939, II, pp. 430, 433.

7. Millar, *Catalogue*, I, p. 98 (II, 150).

8. ibid., p. 93 (II, 143).

9. On its subsequent history see Martin, op. cit. For Marlborough's letter see L. Cust, 'The Equestrian Portraits of Charles I', *Burlington Magazine*, XVIII, 1910–11, p. 207.

10. Whinney and Millar, *English Art 1625–1714*, Oxford, 1957, p. 71.

11. C. V. Wedgewood, *The King's Peace, 1637–1641*, London, 1955; New York, 1959, pp. 19–74.

12. *The Poetical Works of Sir John Denham*, ed. T. H. Banks, Jr, Yale, 1928, p. 70.

13. Richard Lovelace, *Locasta*, ed. W. Carew Hazlitt, 1864, p. 102.

14. *The Martyrdome of King Charles, Or his Conformity with Christ in his Sufferings*, The Hague, 1649, pp. 11–14; see also Richard Watson, *Regicidium Judaicum . . .*, The Hague, 1649, where Charles is alluded to as 'a second Christ' (p. 23). See also medals: E. Hawkins, *Medallic Illustrations*, British Museum [London], 1855, I, p. 342 (191), 344 (196).

15. *Eikon Basilike, The Portraiture of His Sacred Majesty in his Solitudes and Sufferings*, ed. P. A. Knachel, published by Cornell University Press for The Folger Shakespeare Library, 1966; Francis F. Madan, *A New Bibliography of the Eikon Basilike of King Charles I*, Oxford, 1950, Oxford Bibliographical Society Publications, New Series, III, pp. 175–87. Arthur B. Gray, 'The Portrait of King Charles I in St Michael's Church, Cambridge', *The Cambridge Public Library Record*, VII, no. 28, 1935, pp. 101–5; Hatton, *A New View of London*, London, 1708, p. 168. After the Restoration this image was painted in many churches (see *Pepys's Diary*, 2 October 1664).

16. *Eikon Basilike*, ed. cit., p. 28. The crown of thorns was an attribute of some saints, e.g. St Francis, St Catherine of Siena.

17. See Allan H. Gilbert, 'The Monarch's Crown of Thorns', *Journal of the Warburg and Courtauld Institutes*, III, 1939, pp. 156–60.

18. For further history see Helen W. Randell, 'The Rise and Fall of a Martyrology, Sermons on Charles I', *Huntington Library Quarterly*, X, 1946–7, pp. 135–67. See also *Remarks on the Services for November 5th, January 30th, & May 29th, lately erased from the Book of Common Prayer*, London, 1861.

19. *A Form of Common Prayer, to be used upon the Thirtieth of January, being the Anniversary Day Appointed by Act of Parliament for Fasting and Humiliation . . .*, London, 1661.

20. *Parentalia: or Memoirs of the Family of the Wrens*, London, 1750, pp . 330–31.

21. John Evelyn, *Numismata*, London, 1967, p. 335.

22. Horace Walpole, *Anecdotes of Painting in England*, ed. R. N. Wornum, London, 1862, I, p. 271.

23. Allan Cunningham, *The Lives of the most Eminent British Painters*, ed. Bohn, London, 1879, I, p. 33.

24. W. Havard, *King Charles the First: An Historical Tragedy. Written in Imitation of Shakespear*, London, 1737. An earlier play treats Charles I

in a neo-classical vein, the king being Caesar and Parliament the Senate: Alexander Fyfe, *The Royal Martyr, King Charles I. An Opera*, 1705 (but there is no music).

25. These were at Hornby Castle and are now almost entirely in the collection of Lord Brocket. See *Historical and Descriptive Catalogue of the Pictures belonging to His Grace the Duke of Leeds*, London, 1902, pp. 93-4.

26. J. L. Nevinson, 'Vandyck Dress', *Connoisseur*, CLVII, 1964, pp. 166-71.

27. G. Vertue, *Notebooks*, V, Walpole Society, XXVI, 1938, p. 35.

28. A useful survey is in Julius S. Held, 'Le Roi à la Ciasse', *Art Bulletin*, XL, 1958, pp. 139-49.

29. June and August, 1764.

30. Sir Walter Scott, *Woodstock or The Cavalier. A Tale of 1651*, Everyman ed., London, 1906, pp. 99-100.

31. E. Fletcher, *Conversations of James Northcote R. A. with James Ward on Art and Artists*, London, 1901, pp. 76-7.

32. Charles Blanc and Collaborators, *Histoire de Peintres de toutes les écoles*, Ecole Flammande, Paris, 1864, pp. 14, 16.

33. Alfred Michiels, *Van Dyck et ses élèves*, Paris, 1881, p. 389.

34. ibid., p. 388.

35. Max Rooses, *Geschiedenis der antwerpische Schilderschool*, Ghent, 1879, p. 480.

36. Louis Gillet, *La Peinture, XVIIe et XVIIIe siècles*, Paris, 1913, p. 100.

37. Emil Schaeffer, *Van Dyck, des Meisters Gemälde*, Stuttgart & Leipzig, 1909, p. xxxii.

38. Gustav Glück, *Van Dyck*, Stuttgart & London, 1931, p. xliii.

39. A. J. Delen, *Antoon Van Dijck*, Antwerp (no date; c. 1950) pp. 55, 57.

40. C. V. Wedgwood, *Velvet Studies*, London, 1946, p. 100.

41. J. H. Shorthouse, *John Inglesant, A Romance*, London, 1880, p. 12.

42. See S. T. Bindoff, 'The Stuarts and their Style', *The English Historical Review*, LX, 1945, pp. 192-216; D. J. Gordon, 'Hymenaei: Ben Jonson's Masque of Union', *Journal of the Warburg and Courtauld Institutes*, VIII, 1945, pp. 120-28.

43. See T. D. Kendrick, *British Antiquity*, London, 1950, for a complete discussion of the British history.

44. J. Nichols, *Progresses of James I*, London, 1828, I, p. 357.

45. John Gordon, *EVΩTIKOV or a Sermon of the Union of Great Britannie . . .* , London, 1604, p. 26.

46. See F. A. Yates, 'Queen Elizabeth as Astraea', *Journal of the Warburg and Courtauld Institutes*, X, 1947, p. 41; R. Strong, *Holbein and Henry VIII*, London, 1967, pp. 6-7.

47. Thomas Carew, *Poems . . . and . . . Masque*, ed. R. Dunlap, Oxford, 1949, pp. 151-85. This equation of Roman and Ancient British architecture is one of the themes of Inigo Jones, *The most notable antiquity of Great Britain, vulgarly called Stone-Heng*. London, 1725 edn.

48. H. W. Janson, 'The Equestrian Monument from Cangrande della Scala to Peter the Great', in *Aspects of the Renaissance*, ed. A. R. Lewis, University of Texas, 1967, pp. 73-85.

49. Examples rep. in A. M. Hind, *Engraving in England in the Sixteenth and Seventeenth Centuries*, II, pl. 26 (b), 30, 94, 95, 100, 120, 127, 145, etc.

50. See Strong, *English Icon*, pp. 338, 364.

51. Gregory Martin, 'Rubens and Buckingham's "fayrie ile" ', *Burlington Magazine*, CVIII, 1966, pp. 613-18.

52. Julius S. Held, 'Le Roi à la Ciasse', *Art Bulletin*, XL, 1958, pp. 139-49.

53. Quoted by Ruth Kelso, *The Doctrine of the English Gentleman in the Sixteenth Century*, University of Illinois Studies in Language and Literature, XIV, 1929, pp. 154 ff.

54. M. Whinney, *Sculpture in Britain 1530 to 1830*, London, 1964, p. 36. For this the artist was instructed 'to take the advice of the King's riders of great horses for the shape and action of the horse and of his Majesty's figure on the same'. Charles rode the great horse so gracefully 'that He deserved that Statue of Brass which did represent Him on Horseback', *The Works of King Charles the Martyr . . .* , London, 1662, I, p. 115.

55. Elias Ashmole, *The Institution, Laws and Ceremonies of the most noble order of the Garter*, London, 1672, p. 28.

56. See R. Strong, 'Queen Elizabeth I and the Order of the Garter', *Archaeological Journal*, CXIX, 1962, pp. 245-69.

57. There is no modern account of the Garter under Charles and its implications. The reader is referred to Sir Nicholas Harris Nicholas, *History of the Orders of Knighthood of the British Empire*, London, 1841, I, pp. 224-39; G. Beltz, *Memorials of the Order of the Garter*, London, 1841, pp. cvii-cxi; see E. Hawkins, *Medallic Illustrations*, I, p. 253 for a medal of 1629 celebrating the Garter bearing the motto: 'The glory of an ancient order augmented'; M. F. Bond, *The Inventories of St George's*

Chapel Windsor Castle, [1947], pp. 240-42, 243-6.

58. *Art Quarterly*, Spring 1955, pp. 27-42; Michael Jaffé, 'Charles I and Rubens', *History Today*, January 1951, pp. 61-73.

59. Peter Heylyn, *The Historie of that most famous Saint and Souldier of Christ Jesus; St George of Cappadocia* . . . London, 1631, p. 74.

60. ibid., p. 81.

61. ibid., p. 87.

62. O. Millar, 'Charles I, Honthorst and Van Dyck', *Burlington Magazine*, XCVI, 1954, pp. 36-42. The sketch was completed by 1638 as it appears on a list of items to be paid for. Bellori states that the tapestries were for the *gran salone*, i.e. the Banqueting House.

63. Ashmole, *Order of the Garter*, p. 552. See Per Palme, *Triumph of Peace*, London, 1957, pp. 120-28.

64. On the court love cult see Margaret Barnard Pickel, *Charles I as Patron of Poetry and Drama*, London, 1936, pp. 24-38; G. F. Sensabaugh, 'Love Ethics in Platonic Court Drama 1625-1642', *Huntington Library Quarterly*, I, 1938, pp. 277-304. See also Ruth Kelso, *Doctrine for the Lady of the Renaissance*, University of Illinois, 1956, pp. 136-209.

65. *The Dramatic Works of Sir William Davenant*, London, 1872, I, pp. 301-2.

66. *Epistolae Ho-Elianae*, London, 1645, Section 6, Letter XV, (p.29).

67. Aurelian Townshend, *Poems and Masks,* ed. E. K. Chambers, Oxford, 1912, p. 99.

68. ibid., p. 93.

69. Carew, *Poems*, ed. cit., p. 90.

70. *The Poems of Edmund Waller*, ed. G. Thorn Drury, London, 1893, Vol. 1, p. 8.

71. ibid., p. 44.

72. Millar, *Catalogue*, I, pp. 104-5. Millar suggests that this picture may connect with the Greenwich project or celebrate the marriage of Charles's daughter Mary to the Prince of Orange.

73. See e.g. Palme, *Triumph of Peace*, pp. 255-62, on the Cupid and Psyche theme. I do not agree with the theory that originally the centre panel of the Banqueting House ceiling was to depict the nuptials of Cupid and Psyche.

74. D. Schlugheit, 'L'Abbé de Scaglia, Jordaens et "l'Histoire de Psyche" de Greenwich-House (1639-1642)', *Revue Belge d'Archaeologie et d'Histoire de l'Art*, VII, 1937, pp. 139-66.

75. Davenant, *Works*, ed. cit., I, p. 304.

76. Cf. the marriage medal of 1625 on which Cupid scatters lilies and roses: 'Love pours out lilies mingled with roses.' E. Hawkins, *Medallic Illustrations* I, p. 239; Millar, *Catalogue*, I, p. 86 (120).

77. D. J. Gordon, 'Poet and Architect: the Intellectual Setting of the Quarrel between Ben Jonson and Inigo Jones', *Journal of the Warburg and Courtauld Institutes*, XII, 1949, pp. 171-5.

78. *The Works of Ben Jonson*, ed. C. H. Herford, P. and E. Simpson, Oxford, 1947, VII, p. 807.

79. ibid., VII, p. 808.

80. O. Millar, 'Some Painters and Charles I', *Burlington Magazine*, CIV, 1962, pp. 325-30; Millar, *Catalogue*, I, p. 86 (119).

81. *The Poetical Works of Robert Herrick*, ed. F. W. Moorman, Oxford, 1921, p. 26.

82. Ben Jonson, *The Complete Masques*, ed. S. Orgel, Yale U.P., 1969, pp. 458-9.

83. Alfred Harbage, *Cavalier Drama*, New York and London, 1936, pp. 7-27.

84. A. M. Hind, *Catalogue of Drawings by Dutch and Flemish Artists in the British Museum*, London, 1923, II, p. 74 (83).

85. Milton, *Arcades*, lines 44-60.

86. Henry V. S. Ogden and M. S. Ogden, *English Taste in Landscape in the 17th Century*, Michigan U. P., 1955.

87. W. Todd Furniss, 'Ben Jonson's Masques', in *Three Studies in the Renaissance*, Yale U. P., 1958, pp. 112-13

88. *Jonson, Complete Masques*, ed. Orgel, p. 407.

89. ibid., pp. 407-8.

90. Carew, *Poems*, ed. cit., p. 74.

91. Townshend, *Poems and Masks*, ed. cit., pp. 55-78.

92. Francis C. Springell, *Connoisseur and Diplomat*, London, 1963, pp. 74-5.

93. *The Works of James Shirley*, ed. Dyce, London, 1833, p. 277.

94. ibid., p. 277.

95. Cf. C. V. Wedgwood, 'The Last Masque', in *Truth & Opinion*, 1960.

96. Davenant, *Works*, ed. cit., II, p. 326.

97. See Earl R. Wasserman, *The Subtler Language*, Baltimore, 1959, pp. 45-88.

98. Charles H. McIlwain, *The Political Works of King James I*, Cambridge, 1918, Introduction. See also Paul A. Welsby, 'Lancelot Andrewes

and the Nature of Kingship', *Church Quarterly Review*, CLVI, 1955, pp. 400-408.

99. *Political Works of King James I*, p. 3.

100. ibid., p. 307.

101. Pierre Watter, 'Jean Louis Guez de Balzac's *Le Prince*: A Re-evaluation', *Journal of the Warburg and Courtauld Institutes*, XX, 1957, pp. 215-47.

102. ibid., p. 228, where this passage is given in translation.

103. Davenant, *Works*, ed. cit., II, p. 308.

104. ibid., II, p. 311.

105. ibid., II, pp. 322-3.

106. Townshend, *Poems and Masks*, ed. cit., p. 99.

107. See John M. Steadman, 'Heroic Virtue and the Divine Image in *Paradise Lost*', *Journal of the Warburg and Courtauld Institutes*, XXII 1959, pp. 88-105. For the Stuart deification see Millar Maclure, *The Paul's Cross Sermons*, 1534-1642, University of Toronto, Department of English Studies and Texts, no. 6, 1958, pp. 96-101; Malcolm Mackenzie Ross, *Poetry and Dogma*, Rutgers U.P., 1954, esp. pp. 113-34; Ruth Nevo, *The Dial of Virtue. A Study of Poems on Affairs of State in the Seventeenth Century*, Princeton U.P., 1963, pp. 20 ff.

108. See J. Hess, 'Die Gemälde des Orazio Gentileschi', *English Miscellany*, no. 3, Rome, 1952, pp. 159-87.

109. Jonson, *Complete Masques*, ed. Orgel, p. 471.

110. *Luminalia, or The Festival of Light*, 1637, pp. 1-2.

111. McIlwain, *Political Works*, p. 12.

112. Davenant, Preface to *Gondibert*, 1651, p. 16.

113. ibid., p. 18.

114. Hobbes, Answer to the Preface to *Gondibert*, at p. 72, Davenant's *Gondibert*, above.

115. Robert Burton, *The Anatomy of Melancholy*, ed. A. R. Shilletto, London, 1893, I, p. 461.

116. Lawrence Babb, *The Elizabethan Malady*, Michigan State U.P., 1951 and R. Strong, 'The Elizabethan Malady: Melancholy in Elizabethan and Jacobean Portraiture', *Apollo*, LXXIX, 1964, pp. 264-9.

117. Milton, *Il Penseroso*, lines 38-9.

118. ibid., lines 133-7.

List of Illustrations

12. *Charles I bids farewell to his children.* By Jean Raoux, 1722. Oil on canvas. Collection: Lord Brocket. (Photo: National Portrait Gallery.)

13. *Cromwell gazing at the body of Charles I.* By Paul Delaroche, 1831. Oil on canvas. Nimes, Musée des Beaux-Arts. (Photo: Museum.)

14. *The Mocking of Charles I.* By Paul Delaroche, 1837. Oil on canvas. Collection: the Earl of Ellesmere. (Photo: Courtauld Institute of Art.)

15. *Charles I and Cromwell.* By Daniel Maclise, 1836. Oil on canvas. (Courtesy of the National Gallery of Ireland.)

16. *Charles I on Horseback*, detail.

17. Design for scene I of *Coelum Britannicum.* By Inigo Jones, 1634. Pen and brown ink. (Reproduced by permission of the Trustees of the Chatsworth Settlement. Photo: Courtauld.)

18. Costume design for the king in *Coelum Britannicum.* By Inigo Jones, 1634. Pen and brown ink washed with brown (?). (Reproduced by permission of the Trustees of the Chatsworth Settlement.)

19. Equestrian statue of the Emperor Marcus Aurelius. About A.D. 170. Bronze. Piazza del Campidoglio, Rome. (Photo: Anderson.)

20. The reverse of the Third Great Seal of Charles I, 1627–40. London, British Museum. (Photo: Museum.)

21. *The Emperor Charles V.* By Titian, 1548. Oil on canvas. Madrid, the Prado. (Photo: A. and R. Mas.)

22. *Charles I as Duke of York.* By Renold Elstrack, c. 1614–15. Engraving. London, British Museum. (Photo: John R. Freeman.)

23. *Henry, Prince of Wales.* Attributed to Isaac Oliver, c. 1610. Oil on canvas. The Parham Park Collection.

24. *George Villiers, Duke of Buckingham.* By Sir P. P. Rubens, 1627. Oil on canvas. Destroyed, formerly in the collection of the Earl of Jersey, Osterley Park. (Photo: Courtauld.)

25. *Charles I à la ciasse.* By Sir Anthony van Dyck, 1635. Oil on canvas. Paris, Musée du Louvre. (Photo: Museum.)

26. Equestrian statue of Charles I. By Hubert Le Sueur, 1630. Bronze. London, Charing Cross. (Photo: Eric de Maré.)

27. Detail of a design for a triumphal arch at Temple Bar with an equestrian statue of Charles I. By Inigo Jones, 1636. Pen and ink. London, Royal Institute of British Architects. (Photo: R.I.B.A.)

28a, b. *Charles I on Horseback*, details.

29. *Charles I wearing the Garter Star.* By Sir Anthony van Dyck, c. 1632–40. Oil on canvas. Dresden, Staatliche Kunstsammlungen. (Photo: Museum.)

30. *St George and the Dragon.* By Sir P. P. Rubens, 1629. Oil on canvas. London, Buckingham Palace. (Reproduced by gracious permission of H.M. the Queen.)

31. *A Procession of the Knights of the Garter.* Engraved by Richard Cooper after a sketch by Sir Anthony van Dyck, *c.* 1638. Collection: the Duke of Rutland. (Photo: Royal Academy.)

32. *Henrietta Maria.* By Sir Anthony van Dyck, *c.* 1632. Oil on canvas. Windsor Castle, Royal Collection. (Reproduced by gracious permission of H.M. the Queen.)

33. *Cupid and Psyche.* By Sir Anthony van Dyck, *c.* 1639-40. Oil on canvas. London, Buckingham Palace. (Reproduced by gracious permission of H.M. the Queen. Photo: National Gallery.)

34. *Charles I and Henrietta Maria depart for the chase.* By Daniel Mytens, *c.* 1630-32. Oil on canvas. Hampton Court, the Royal Collection. (Reproduced by gracious permission of H.M. the Queen. Photo: A. C. Cooper Ltd.)

35. *Charles I and Henrietta Maria.* Attr. Daniel Mytens, *c.* 1630-32. Oil on canvas. Welbeck Abbey. (Photo: A. C. Cooper Ltd.)

36. *Charles I and Henrietta Maria.* By Sir Anthony van Dyck, *c.* 1632. Oil on canvas. Kremsier, Archbishop's Palace. (Photo: Ōtakar Kleps̆ Kroměřtž.)

37. Design for *The Shepherd's Paradise.* By Inigo Jones, 1633. Pen and brown ink. (Reproduced by permission of the Trustees of the Chatsworth Settlement.)

38. *Lord Wharton.* By Sir Anthony van Dyck, 1632. Oil on canvas. Leningrad, the Hermitage. (Photo: National Gallery of Art, Washington, D.C.)

39. Title page to part I of Honoré d'Urfé's *Astrée* (Paris, 1615). Paris, Bibliothèque Nationale. (Photo: Museum.)

40. *Trees on a Hillside.* By Sir Anthony van Dyck, 1634. Pen and sepia. London, British Museum. (Photo: John R. Freeman.)

41. *Charles I on Horseback*, detail.

42. *Minerva protects Pax from Mars.* By Sir P. P. Rubens, 1629. Oil on canvas. London, National Gallery. (Photo: Museum.)

43. Design for scene II of *Salmacida Spolia.* By Inigo Jones, 1640. Pen and brown ink. (Reproduced by permission of the Trustees of the Chatsworth Settlement.)

44. Costume design for Charles I as Philogenes in *Salmacida Spolia.* By Inigo Jones, 1640. Pen and brown ink, corrected in places with white

chalk or paint. (Reproduced by permission of the Trustees of the Chats-worth Settlement. Photo: Courtauld.)

45. Design for the final scene of *Salmacida Spolia*. By John Webb, 1640. Pen and brown ink. (Reproduced by permission of the Trustees of the Chatsworth Settlement.)

46. *The Liberal Arts and Sciences.* By Orazio Gentileschi, after 1626. Oil on canvas. London, Marlborough House. (Reproduced by permission of H.M. the Queen. Photo: M.P.B.W.)

47. *Buckingham presents the Liberal Arts to Charles I and Henrietta Maria.* By Gerard van Honthorst, 1628. Oil on canvas. Hampton Court, the Royal Collection. (Reproduced by gracious permission of H.M. the Queen.)

48. *Charles I on Horseback*, detail.

49. Sketch for an equestrian portrait. By Sir Anthony van Dyck, *c.* 1635. Oil on panel. Collection: the Earl of Pembroke. (Photo: A. C. Cooper Ltd.)

Index

Bold numbers refer to illustration numbers